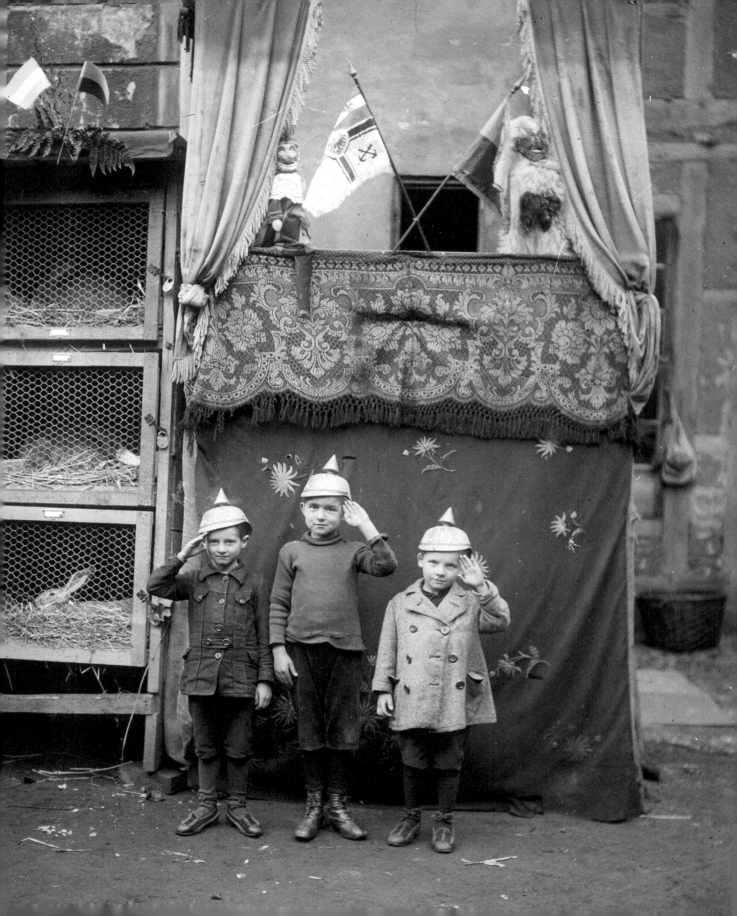

BEYOND THE BATTLEFIELDS

Käthe Buchler's Photographs
of Germany in the Great War

Left: *Children in Uniform, Punch and Judy* (undated)
Inside front cover: *Flowers, Still Life* (undated)

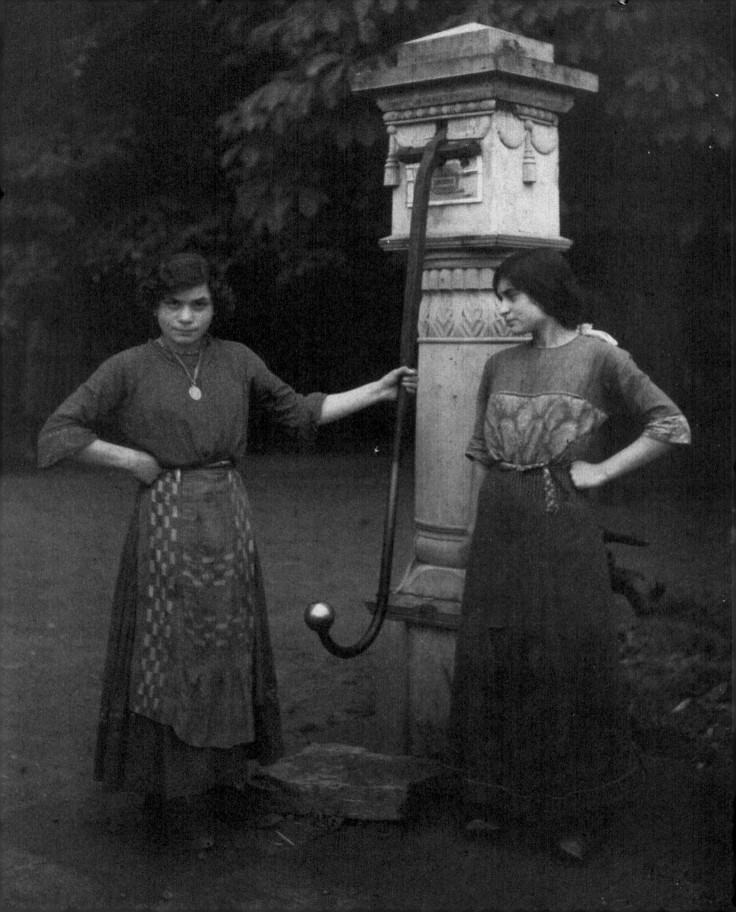

Contents

Left: *Sinti*, Steterburg 1914
Following page: *Gisela, Inge,*
Walther Roedenbeck and Friend c. 1928–30

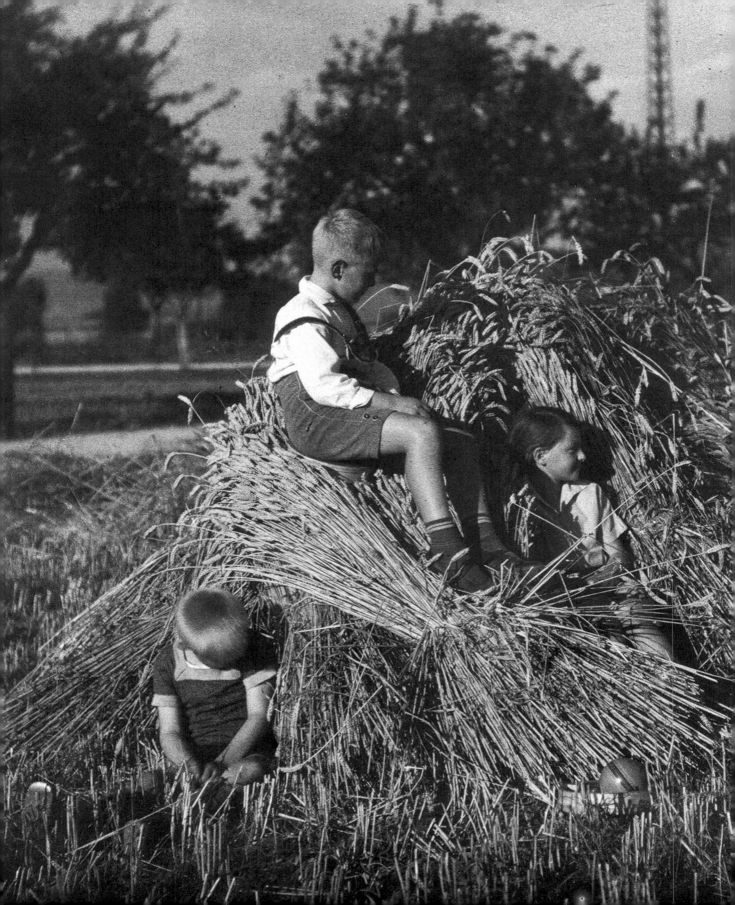

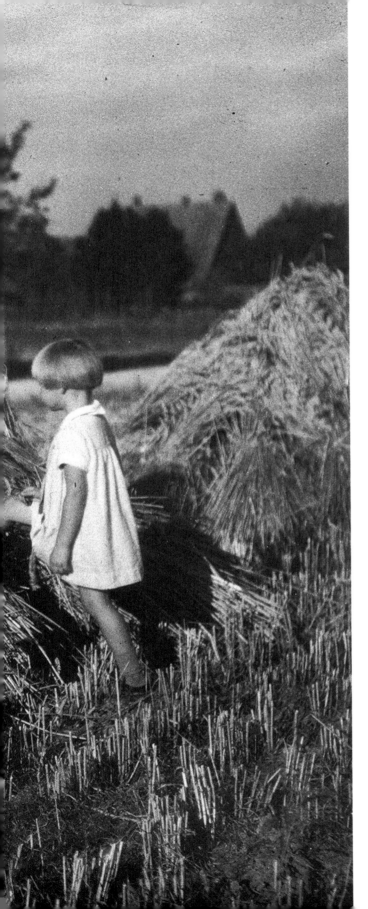

Foreword

Sarah Lloyd

The exhibition *Beyond the Battlefields Käthe Buchler's Photographs of Germany in the Great War* is the first time that Käthe Buchler's work has been shown outside Germany. Between October 2017 and May 2018, *Beyond the Battlefields* toured Birmingham, Manchester and Hatfield with images selected from the substantial archive of black-and-white negatives, glass plates and colour Autochromes, which Buchler's family bequeathed to her home city of Braunschweig. The exhibition is an opportunity for international audiences, including historians and photographic specialists, to examine Buchler's work in detail and to compare it with that of other, often better-known photographers working in the same period.

In depicting the minutiae of daily life against the backdrop of war and its aftermath, Buchler's remarkable photographs also speak across the intervening century and the origins of this tour owe much to that capacity.

In April 2015, curator Matthew Shaul made a chance visit to the Museum für Photographie in Braunschweig. A few weeks later, he arrived in my office with two books of photographs by Käthe Buchler, whose name and works were then unknown in Britain. Opening a page at random, two women walked towards me, their skirts a blur of movement and weather. From the early 1900s until her death in 1930, Buchler had represented the social fabric of a north German town and life in an upper-middle-class family. In expressing her own painterly view of the world, in monochrome and astonishingly limpid colour, her subject matter and chronology offered a distinctive vision. Hers were not the familiar images of the years leading up to, during and after the First World War. Instead they raised the intriguing possibility of presenting an interpretation of the conflict from the perspective of women and children, of dislodging national stereotypes and challenging those of us working in the UK to open fresh perspectives on the war's centenary and set it in new contexts.

From the moment when Matthew stepped off the train at Braunschweig and was reminded by the museum's collection of conversations he had had with colleagues back in Hatfield, this project has exemplified the power of serendipity.

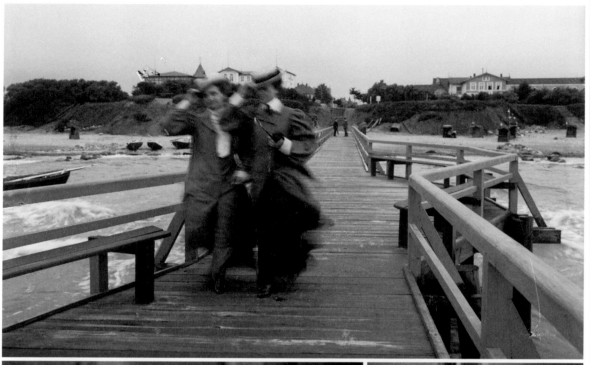

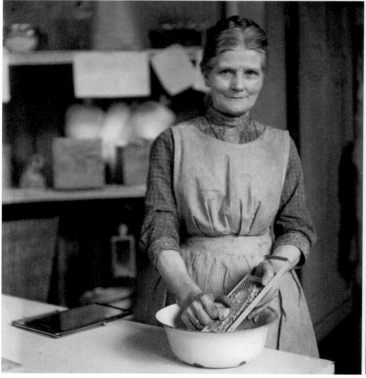

It was serendipity that Buchler's images resonated so strongly with two of the First World War Engagement Centres funded by the UK's Arts and Humanities Research Council: *Everyday Lives in War*, based at the University of Hertfordshire, Hatfield, and *Voices of War and Peace* in Birmingham. Both Centres share a commitment to community-based research and to the historical experiences of those frequently on the margins of national, mainstream media or official narratives.

Buchler's photographs have a tendency to do their own persuading, so we immediately saw how an exhibition might stimulate the communities we work with, as well as ourselves, to bridge the gulf of time and historic lines of conflict.

We were not mistaken. Typical visitor comments included: 'Makes you question why did we go to war with them because they are the same as us' and 'it has really prompted me to think about what my grandmothers' and family members' experiences of World War One were, and what life would have been like'.

In Birmingham, the inclusion of local material in the exhibition allowed the different British and German histories to look one another in the face. In Manchester, students responded creatively to Buchler's images, giving them new meaning in the present. In Hatfield, a theme of Witnessing War invited viewers from all walks of life to record what they saw in the photographs, a process that celebrates the powerful contribution of community-based research to understanding the war and its legacies.

This catalogue draws together different elements from the tour. Longer essays address the role of amateur photography in documenting war and mediating the legacy of conflict. They consider how development of the medium and the infrastructure of reproduction and dissemination changed the way people saw the world and attitudes to news media.

Set in context, Buchler's story is that of many women who adopted the photographic medium and inhabited its landscape, changing society's expectations about women's technical and organisational abilities. The two Centres also invited researchers from centenary projects to respond to an image chosen from the exhibition. These responses demonstrate how the past is in continual engagement with the present, a conversation that shapes both memory and ideas about the future.

This exhibition is also about collaboration – between Germany and the UK, across the First World War Centres, around the four exhibition venues in Birmingham, Manchester and Hatfield, across a network of diverse researchers. We thank Barbara Hofmann-Johnson and the Museum für Photographie Braunschweig for supporting this project, which above all demonstrates the benefits of international cross-cultural exchange. Matthew Shaul made the intellectual leap that set the whole process going; Nicola Gauld, Ian Grosvenor, Melanie Tebbutt and Jacqueline Butler joined us to put the exhibition in motion. The Arts and Humanities Research Council and the University of Hertfordshire provided the major finance. Community projects *Basketry Then and Now, Investing in Children World War One, All the Nice Girls* and *Disability History Scotland* have generously given their time and ideas, for which we are very grateful. Working with them, as well as with many other community groups, has been the guiding principle of the First World War Engagement Centres. Our experience with *Beyond the Battlefields* is a testimony to the creative energy, imagination and insight that is sparked when academic research, the international network of photography museums and community research intersect.

Sarah Lloyd
Everyday Lives in War

Above: *Two Women on the Pier* (undated)
Below left: *Woman Grating Potatoes* (undated).
Below Right: *Buchler Family Home,* Braunschweig 1914

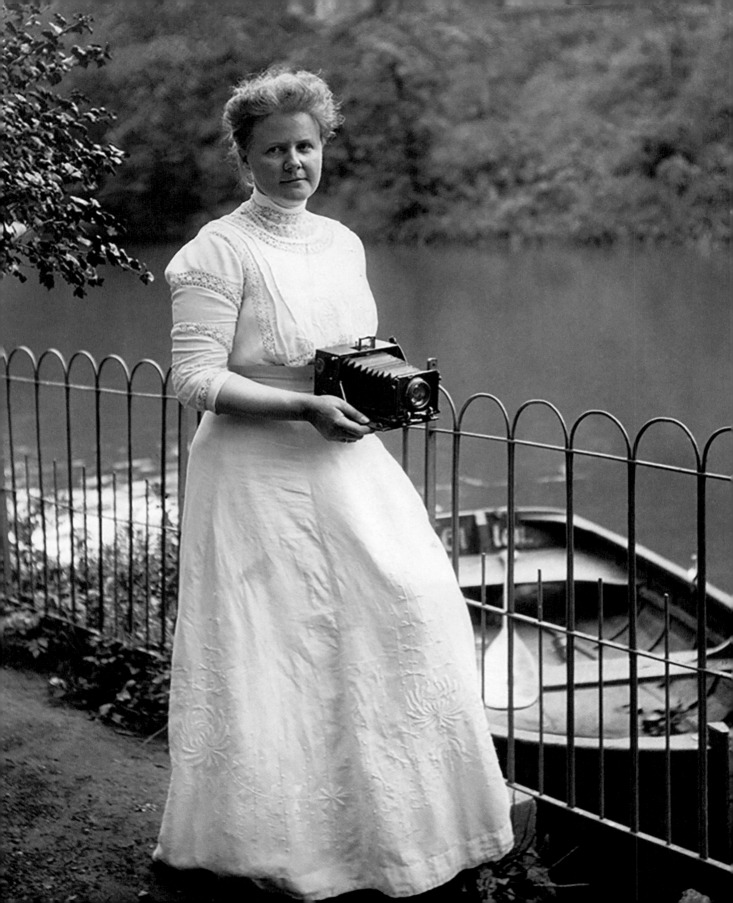

Introduction

Discovering a Treasure in the UK: Käthe Buchler's Photographs of Germany in the Great War

Barbara Hofmann-Johnson

Käthe Buchler (1876–1930) bequeathed a photographic legacy to the Museum für Photographie Braunschweig, which, historically, is one of the most significant treasures of early-twentieth-century image-making.

Perhaps surprisingly, for a visual archive of this quality, Buchler's work has remained unexplored and undiscovered outside its immediate locality and has lacked the international recognition and comparisons with the work of other photographers that would place it within its proper context.

The exhibition *Beyond the Battlefields: Käthe Buchler's Photographs of Germany in the Great War*, organised by the AHRC-funded First World War Engagement Centres at the University of Birmingham and the University of Hertfordshire with exhibition venues in Birmingham (October – December 2017), Manchester (February – March 2018) and Hatfield (March – May 2018), makes a very important contribution to addressing this deficit.

Born Katharina von Rhamm in Braunschweig in the state of Lower Saxony in Germany, she married Walther Friedrich Theodor Buchler, an industrialist's son and proprietor of the local quinine factory in 1895. Family life, her two children, Walther jr. and Ellen, travels with her family to the seaside, to Switzerland and even to the UK became the central themes of Käthe Buchler's photographic oeuvre in the years leading up to the First World War.

Self Portrait c.1905

Engelburg (Switzerland), 1930

Ivy and Eric Charles Buchler, England c.1913

Opposite Top: *Ulrich von Rhamm and Irmgard Hagenberg* c.1928

During the war itself, in what was the most 'public' phase of her career, Buchler produced historic and unexpectedly intimate photographs of daily life in Braunschweig, the life of the city's hospitals (Braunschweig having been designated a 'hospital city'), soldiers' lives and the series '*Women in Men's Jobs*'. Like many women of the upper-middle class, Buchler was a leading figure in local women's associations and the Red Cross, this in particular enabled her to secure largely unrestricted access to Braunschweig's extensive medical facilities. Wealthy and privileged, she was the beneficiary of an

early education in art and culture. As a young woman she received tuition in painting, and many of her later photographs – including those made during the First World War – recall the pictorial construction, compositions and themes of nineteenth- and-early-twentieth century painting.

Her decision to commence a photographic career in 1901 was significantly influenced by her brother-in-law Friedrich Ritter von Voigtländer, whose company was one of the principal lens and camera producers in Braunschweig's fast developing optics sector. Her first camera, a twin lens Voigtländer, was a present from her husband.

Initially self-taught, she took photographic courses at Berlin's Lette Academy from 1906, which unusually for the time, admitted women. In Braunschweig she began a longstanding professional collaboration and exchange with the photographer Wilhelm Müller and began to present her photographs at well received public slide shows in Berlin and Braunschweig.

As an important collection of twentieth-century photography, Buchler's photographic legacy comprises over 1000 black-and-white glass-plate negatives in 9 x12 cm format, sheet film negatives, approximately 330 black-and-white slides, contact prints, and, most importantly, very many prints which were preserved in family albums.

The collection also includes about 250 coloured Autochrome slides. Developed by the Lumière brothers in Lyons Käthe Buchler began working with this early photographic colour process some years after its introduction in 1904. Autochrome uses potato starch as a carrier for additive colour layers, the images it produces are 'photographic' in character but very clearly recall the aesthetics and colours of painting.

In 2006 Käthe Buchler's family donated her photographs to the Museum für Photographie Braunschweig. The museum, which occupies two listed neo-classical former gatehouses, possesses neither the space nor the facilities to properly care for this unique visual resource, and in a remarkable and fruitful example of cross-departmental collaboration, we have been able to work with our colleagues at Braunschweig's City Archives to catalogue, explore and preserve the collection using the most modern storage, research and conservation techniques.

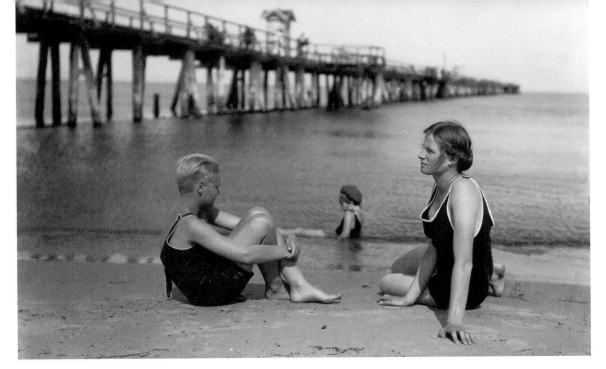

As early as 1980, the art and photographic historian Bodo von Dewitz (1950–2017) initiated a research project around Buchler's work in collaboration with her family, compiling the thematic groups and content-related categories which are still in use today.

In 2006, a first extensive exhibition project at the Museum by Miriam Jung and Franziska Schmidt examined the Autochromes after they were donated to the museum.

In 2012, Florian Ebner, who was director of the Museum für Photographie from 2009–2012, exhibited Buchler's idyllic familial and socially-orientated work in a combined exhibition with the Städtisches Museum Braunschweig. The exhibition was curated to present the work as Buchler herself might have presented it, comprising slide projections and prints.

Beyond the Battlefields has been in preparation since 2016, when curator Matthew Shaul initiated discussions with the Museum's former director Gisela Parak about the possibility of bringing Käthe Buchler's work to the UK. My former colleague Theresia Stipp (a technical trainee at the time) and Regine von Monkiewitsch (as chair of the museum's board) initially progressed the project after Gisela Parak left the Museum. Theresia, who has also since left the museum, was in large measure responsible for the organisation of the project from the museum's side after my appointment as director in October 2017, and

I would like to take this opportunity to thank her and the curators Jacqueline Butler, Melanie Tebbutt, Nicola Gauld and Matthew Shaul for their efforts.

Käthe Buchler's photographic works range in their subject matter between private and artistic themes and social documentary. This exhibition comprising predominantly modern prints offers the opportunity to compare and contrast her work with some of her many contemporaries (including of course British contemporaries) who have made important contributions to photographic history.

We are delighted at the new and thoroughly well-deserved international recognition that Käthe Buchler's work is receiving, for the collegial exchange and the wonderful cooperation the project has generated.

The analysis and consideration of historical themes provide opportunities for explanation and understanding, which transcend international borders and generate positive outcomes for our future co-existence. These are outcomes which, undoubtedly, Käthe Buchler herself would have wholeheartedly supported. We must hope that in the future we can exploit the multiple opportunities this fruitful cooperation has offered up.

Barbara Hofmann-Johnson, Director
Museum für Photographie Braunschweig

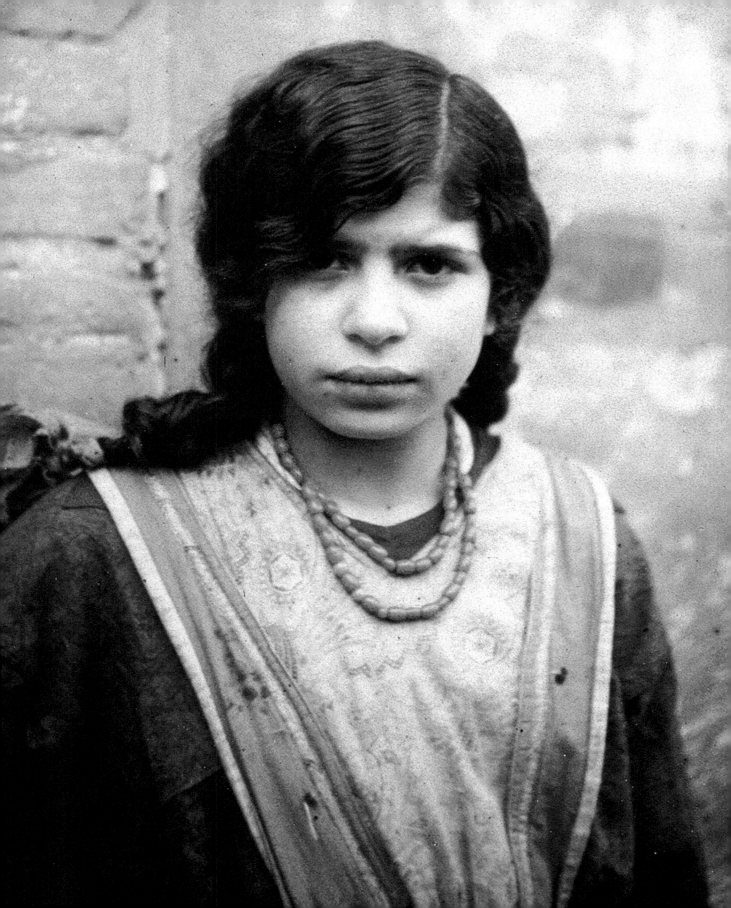

Public Faces, Private Lives

Experimentation and Innovation in Käthe Buchler's Photography before, during and after the First World War.

Matthew Shaul

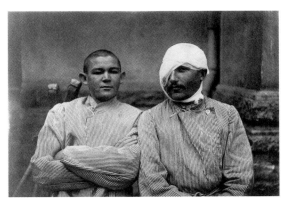

Two Wounded Soldiers, c.1915–16
Left: *Sinti Woman,* Sterterburg 1914

To British eyes, Käthe Buchler's photographs, particularly those made during the First World War, are profoundly unexpected. While they reference local (and definitively German) impacts of global conflict, unlike much of what we in the UK have seen, they almost exclusively represent the war's social history. Typically Buchler presents images of exquisitely dressed and well-drilled German children recycling waste for the war effort or working at the local children's home. Dislocation, destruction or the conflict itself are referenced only obliquely in her images of wounded soldiers and the queues forming outside a local grocery store.

Buchler's photographic legacy – created at a time which predates today's point-and-shoot aesthetics – is noteworthy, in particular, for its warm humanity and its insightful aesthetic. Perhaps unexpectedly, given her remarkable skill in managing large groups of subjects through the then cumbersome process of portrait photography, Buchler was profoundly hard of hearing. This complicated her relationships with others throughout her life and it has been suggested that the sharpness of her visual acuities and her singlemindedness in mastering the technical challenges of early-twentieth-century photography emerged from the desire to create a parallel world of images for herself, and a connection with others to compensate for her deafness.[1]

Like many other women of the upper-middle class, Buchler actively supported a number of good causes. Prior to the war, she contributed to the work of the 'House of Salvation' – the local children's home – producing tightly staged and intensely choreographed images of the institution's Christian and utilitarian mission.[2]

[1] Solf, Sabine, 'Das war also unsere Großmutter' in Ebner, Florian & Meinhold, Jasmin (eds) *Käthe Buchler – Fotografien Zwischen Idyll und Heimatfront,* Museum für Photographie Braunschweig, 2012 p191

[2] Von Dewitz, Bodo 'Kinderfürsorge und 'Bürgerliche' Photografie, Das Braunschweiger Rettungshaus in Aufnahmen von Käthe Buchler' in Sachsse, Christoph & Tennstedt, Florian (eds) *Jahrbuch der Sozialarbeit* 4, Rowohlt Verlag, Hamburg 1981 pp 403–407

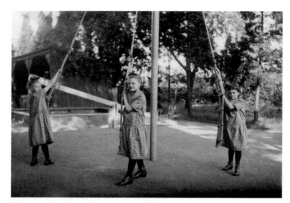

Three girls from the House of Salvation with Swing, c.1913

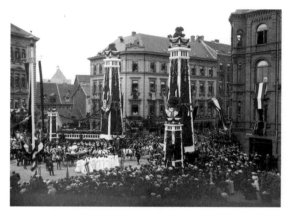

Entry of the Ducal Couple into Braunschweig, 1913

With the onset of war in 1914 – and Braunschweig designated a 'Hospital City' – she turned her attention to documenting the care of wounded troops in local hospitals. She also recorded the work (often the work of children) for the state recycling company and created extraordinarily revealing images like those found in her series *Women in Men's Jobs*.

Using her photographic skills to document the war effort was the most useful and meaningful way that Buchler could contribute (and crucially in Wilhelmine Germany's tightly structured society, be seen to be contributing).[3] Her images are an expression of duty and obligation to the cause of national salvation.

The many thousands of images that she produced and developed in her own darkroom, before and during the war, convey stability, uprightness, deference and hegemony. The well-ordered society that Buchler captured, however, is also a document of Imperial Germany's swansong: a society on the cusp of revolutionary change that was to sweep away continental Europe's dynastic empires and the social order which supported them.

The transition between pre-war Germany's thrusting economic self-confidence and the crisis of the armistice of November 1918, the Kaiser's abdication and exile, which marked the war's end is neatly expressed in the stark contrasts between two of Buchler's photographs: one taken in Braunschweig in 1913 during the last major gathering of European royalty before the outbreak of the First World War, the other of orderly queues forming outside a grocer's shop in 1917.

[3] Von Dewitz, Bodo *Photographien aus Braunschweig von Käthe Buchler geb. Von Rhamm,* Arbeitsbericht aus dem Städtischen Museum Braunschschweig, Bd.37, p9

In November 1913, lavish festivities marked the marriage of Ernst Augustus, Duke of Braunschweig and the son of the British Duke of Cumberland to the Kaiser's daughter Viktoria Luise,[4] followed by the royal couple's coronation as the ducal rulers of the province. In November 1918, only five years after the pageantry of a marriage, which had occasioned the largest gathering of reigning European monarchs since German unification, the Duke was forced to abdicate by a local council of workers and soldiers as the German Empire collapsed into revolution.

Buchler's photograph of shoppers patiently waiting for rationed groceries (*Food rationing in War Time, Queue of Shoppers at Hauswaldt's,* 1916–18), which clearly manifests the disruptions to the supply of basic foodstuffs imposed by the stranglehold of war and allied blockade, offers a clue to why Germans, who had greeted war in 1914 as a moment of national awakening, had lost faith in the political system and its structures of patronage and privilege.

Buchler was part of an emerging democracy of image-making, which developed out of an increasingly accessible and inexpensive photographic reproduction and distribution system. This changed what photographers could produce and how their images were received. Photography could be immediate, informal and unstaged, and amateur photography, which was understood as a source of uncensored news, undoubtedly affected the course of the war and how it was perceived by the German public.

This changed relationship with photographic imagery began to evolve before the First World War, and could manifest in private and domestic contexts: Buchler's photograph of her son playing cowboys and Indians before the war in 1909 attests to the beginnings of the 'family snapshot' aesthetic, the evolving relationship between the producer and the consumer of photographs[5] and, tangentially, to the massive popularity of the stories of the American West in pre-First-World-War Germany[6]. Equally, between 1914–18, amateur 'soldier photographers' using specially designed 'soldier cameras' and mobile darkrooms provided a flow of 'unfiltered' and unedited personal impressions in the images they sent home from the front as postcards.

Revealing profound naiveté about the power and propaganda value of photography, the Wilhelmine state not only made no attempt to restrict 'soldier photography' but even relied on it to document the war effort. The Bild und Film Amt (Military Picture and Film Office) boasted at the end of 1915 that it had collected 45,000 individual images made by amateurs.

It wasn't until 1916 that an official, structured and propagandistic use of photography was introduced as the German war machine began to understand the power of images and how these might be used to counter war-weariness as the conflict became a stalemate.[7]

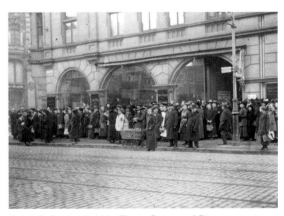

Food Rationing in War Time, Queue of Shoppers at Hauswaldt's, 1916–18

4 Ludewig, Hans Ulrich, 'Braunschweig Im Ersten Weltkrieg', Ebner, Florian & Meinhold, Jasmin (Eds), *op. cit.* pp 158–165
5 Zelt, Natalie 'The Changing Ways in which Photographers' Images Have Reached the Public Eye', in *WAR / PHOTOGRAPHY,* Tucker, Anne, Michaels, Will & Zelt, Natalie (eds) MFAH, Houston 2012 p18.
6 The mythology of the American West was popularised in *Winnetou and Old Surehand* a series of tales written by Karl May published between 1875–1910.
7 Von Dewitz, Bodo, 'German Snapshots from World War 1' in Tucker, Anne, Michaels, Will & Zelt, Natalie (eds) MFAH, Houston, *op. cit.* p 154

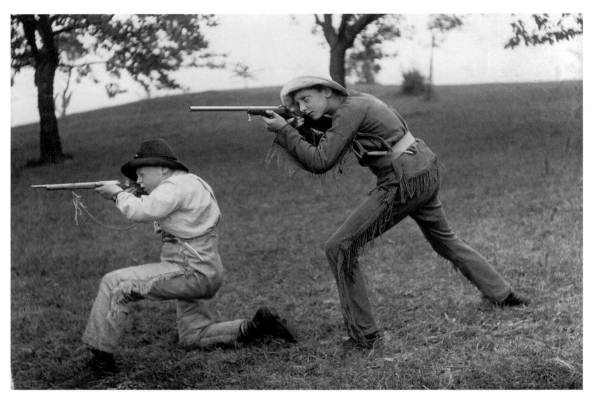

Either coincidentally, or because of changes in the status of and tighter control of the photographic image, the most public and officially sanctioned phase of Buchler's working life as a photographer was between 1914–16 when her images were used to promote the work of the Red Cross. Her work was also published after the war (and after her death) in books celebrating local heritage and folk traditions, in local histories and, as late as 1934, in a history of the work of the Red Cross in wartime.[8]

She was also enthusiastically received in regular public slide shows that were reported in the local and regional press: in late 1916, a report of a slide show at the International Society for the Advancement of Photography in Berlin describes her 'forensic' approach to recording the work of, and the rewards earned by, child workers for the State Recycling Company as well as her 'characterful' photographs of women working as ticket collectors, window cleaners and postwomen.

More rigorous oversight of photography after 1916 combined (presumably) with the scarcity of chemicals and materials as the war progressed may account for the fact that she produced very little work after 1916, only resuming her work as a photographer in the post-war period.

Her work in the 1920s and 30s, up to her untimely death in 1930, is substantially marked by colour photography using the Autochrome process, the world's first commercially available colour photographic process which she had begun using in 1913.[9]

The luminosity and the 'painterly' characteristics of Buchler's colour transparencies are quite unlike anything in modern photography. Her technical skill and determination to work through Autochrome's long exposure times to create spontaneous and even photojournalistic images is testament to the seriousness with which she took her photographic vocation, amateur she may have been, but she was certainly no hobbyist.

8 Ebner, Florian & Meinhold, Jasmin (eds) *op. cit.* p172
9 The Autochrome process, producing colour images using pigmented potato starch, was patented by the Lumière Brothers in Lyon, France in 1904.

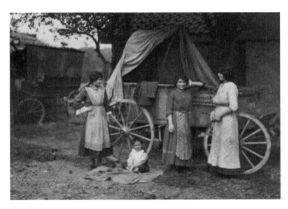

Sinti Family, Steterburg 1914
Opposite:*Walther Buchler & Friend Playing Cowboys and Indians,* c.1911

A particularly fine example of this is a series of a Sinti (Gypsy or Roma) family she captured on a family outing to the nearby city of Steterburg in 1914. Not only would it have been highly unusual for a middle-class woman even to have approached such a family in 1914, but the piercing eyes of one of the young Sinti women (see page 16 and opposite) and the intimate nature of her portrait evidences Buchler's ability to gain and maintain the confidence of a social group who lived far outside the norms of respectable Wilhelmine society.

What is clear is that, although much of her work was private, she was working at a hugely transitional moment in the medium's evolution. A mere five years after Buchler's death, the American photographers who produced the images we know collectively by the acronym FSA (the photographers of the Farm Security Administration)[10] began to take their first faltering steps into the world of colour photography using the new Kodachrome process and to develop colour photography as we know it in the modern era.

While many of her images may be described as early social documentary, her choice of motifs, the decision to make images which function neither as snapshots, nor documentary, nor journalistically, but perhaps as 'art' suggests that Buchler was a pioneer employing a visual grammar far in advance of its time.

Matthew Shaul is an independent curator and director of Departure Lounge, Luton. He organised and curated the touring exhibition *Do Not Refreeze – Photography Behind the Berlin Wall* between 2007 and 2011. He was artistic director at UH Galleries until 2017.

[10] Jackson, Bruce : *Full Colour Depression, First Kodachromes from America's Heartland*, Centre Working Papers, SUNY, Buffalo, 2011 p41. The Farm Security Administration (FSA), its precursor, the Resettlement Administration (RA) and latterly the Office of War Information (OWI) was established by the Roosevelt Government in 1935 to combat rural poverty. It employed photographers like Walker Evans and Dorothea Lange (et al) to record the process of resettling rural communities. In the process producing a visual document which enabled America to 'comprehend its own vastness and diversity'. Over time the FSA photographs have become a monument to the world's visual heritage.

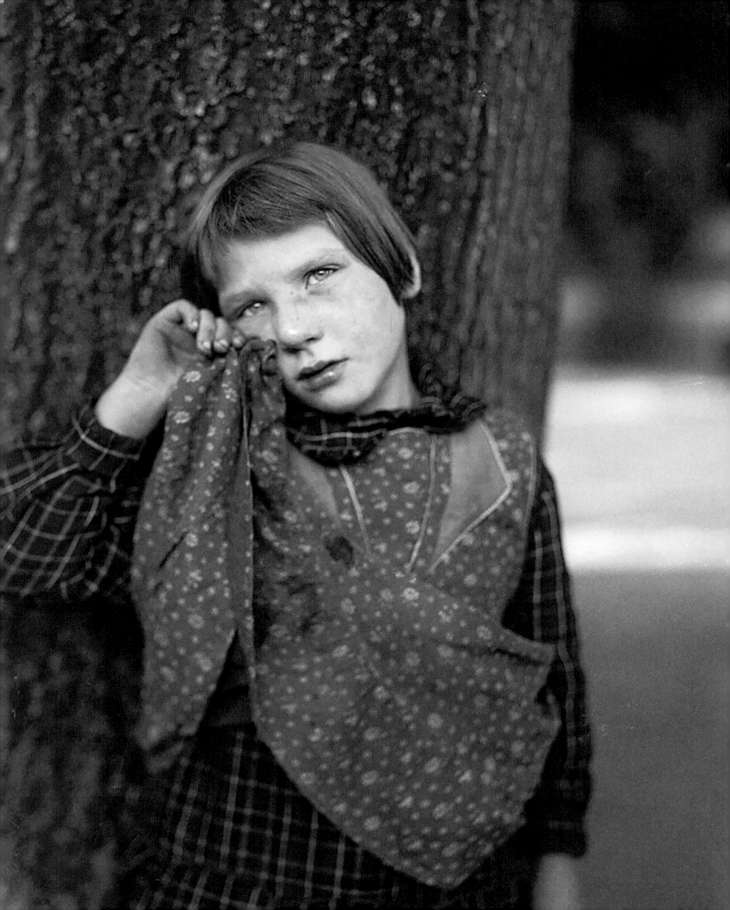

'Shiny Shoes and Bare Feet': Käthe Buchler's *Heimatfront* Photographs of Children

Nicola Gauld and Ian Grosvenor

Photographs physically capture a moment in time, a moment privileged over other instances which are lost. They are a 'record of things seen', a process 'for rendering observation self conscious',[1] and the 'creative treatment of actuality'.[2] When we look at photographs, we have the expectation that we can draw out some meaning but, as John Berger pointed out, there is an 'abyss' between the moment recorded in a photograph and the moment of looking. As he puts it: 'it is when we find a photograph meaningful that we lend 'it a past and a future'. If the meanings we take from images are framed by the context in which we encounter them, it follows that there is also a need to examine 'the life of an image' and to consider 'its circulation and its currency as it moves through time and space from context to context'.[3] The properties of an image do not change, but over its material existence it accrues different meanings as it enters into relationships with new contexts and audiences.[4] These observations about the nature of photography will come as no surprise to anyone who has engaged in visual dialogues with the past and the present, but serve here as a framing device for how we want to look at the representation of children in this essay. The context within which we are looking is a knowing one: we know the future beyond the moment captured in Käthe Buchler's photographs.

Unknown Girl (undated)

1 Berger, John, in *John Berger Understanding a Photograph,* Dyer, Geoff (ed.) London, 2013, pp 18–19
2 Grierson, John, 'The Documentary Producer' in *Cinema Quarterly*, 2, 1933, pp 7–9
3 Berger, John, 'Appearances, The Ambiguity of the Photograph' in Dyer, op.cit, pp 63–4
4 Wilson, John A. 'Context as a Determinant of Photographic Meaning' in Evans, J. (ed.) *The Camerawork Essays. Context and Meaning in Photographs* London, 1997), p 57

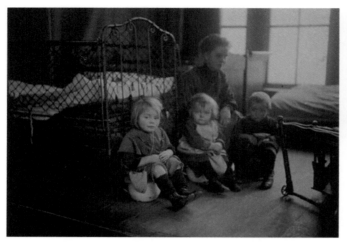

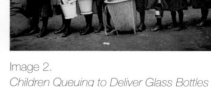

Image 2.
*Children Queuing to Deliver Glass Bottles
for Recycling* c.1915

Image 1.
At the War Nursery (undated)

Looking is always followed by questioning. Photographs, as Alan Trachtenberg noted, 'make novelists out of us, testing our skills … imagining plausible narratives'.[5] In what follows we comment on four of Käthe Buchler's photographs of children taken in Braunschweig during and after the Great War. The short commentaries are a mixture of observable 'facts' and speculative observations. The former being a product of the evidential and documentary value of photography. What can we see?

Image 1. Three children appear to be sitting on chamber pots. A young woman is sitting or crouching behind them. The children gaze into the camera lens, but the young woman looks away. The children are close in age. Are they siblings? The archive catalogue tells us they are in the war nursery. Why are they there? Have they been abandoned or are their parents involved in the war effort, father[s] at the front, mother[s] undertaking 'men's jobs'? Is the young woman their carer? The children hold their hands together in their laps, but only the girl at the front of the image is in focus. Have they been told to sit still? The girl's face conveys a mixture of resignation and bemusement.

She is the transition point between light and shadow. The diagonal line of the floorboards intersects the composition, which is dominated on the left by a metal cot with moveable sides and on the right we can see a baby-walker.

Image 2. Eight children ranging in age are lined up in a queue, six girls and two boys. All but one of them wears a thick winter coat, and all are wearing shiny polished boots or shoes. Each of them is carrying some form of container – bucket, basket, bottle. The hair of the girls is clean and gathered with ribbons, hair grips or plaited. The light catches their faces, pale against the dark background of the building at the back where we can see a cart. Sacks are piled on the left of the picture and the girl nearest to them looks as though she is about to engage in a transaction with someone outside the frame. Two of the girls are wearing satchels. Are they going to or coming from school? Where is our gaze directed? Is it to the two boys at the centre who are focused on the contents of a deep wicker basket which they both jointly hold and which is attracting the gaze of three of the girls or is it the girl on the right who is the only one staring at the camera? The materiality of the image is striking in its detail.

5 Trachtenberg, Alan *The Group Portrait in Multiple Exposures*
(New York: Independent Curators Incorporated, 1995), p 17

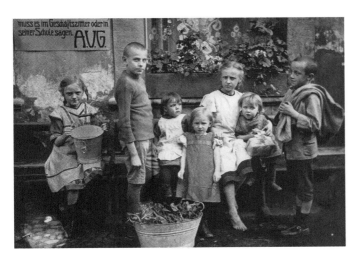

Image 3.
Children from the A.V.G. (undated)

Image 3. Seven children, two boys and five girls, are posed outside a building with a large window in front of which is a box full of flowers. Is it late spring or summer? There is a decorated lace curtain which suggests domestic rather than institutional use, but part of an official notice is also visible on the building. It references the A.V.G. (the Abfallverwertungs Gesellschaft – The State Recycling Company) and announces to all concerned that times have been allotted as to when children can collect recyclable waste from homes and businesses. Four of the children are sitting on benches and two are standing, and all but two of them are looking directly at the camera. The eldest, a girl, physically touches two of the smaller children in a familial way. Unlike all of the others her feet are bare. Her expression is questioning. None of the children are smiling. The jumper of the oldest boy is worn, holed and too small. The second boy has an empty sack across his shoulder, one girl holds a metal bucket and another holds a small paper basket. In front of them is a two-handled metal container full of vegetation. The girl standing nearest to the container holds a large leaf in her left hand.

In each of these images the children have been brought together for a particular purpose giving them a group identity through the very act of assembling. We see children being themselves or a version of themselves but at the same time the individual is lost in a role of subordination to the event, a moment of collusion between Buchler and her subjects. What did Buchler say to the children in these photographs? How did she go about organising them? Were there processes of negotiation? Were compromises made? What of the temporal dimension associated with organising the frame? What happened after this captured moment? We can only speculate.

What evidence is there in these images of conflict shaping the 'architecture' of their childhood? Children in the nursery, would have some memories of family life and social rituals before the war, and while families were reconfigured in the absence of one or both parents, it would have been in the years immediately following the war's end that they would have experienced the greatest disruption and reordering of their lives as severe food shortages and local political conflict damaged the fragility of family life. By 1921 one million German children a day were being fed by Quaker-run soup kitchens.

Older children were a reservoir of cheap labour during the war years, often organised through schools, disrupting the normal routines of schooling. Children were mobilised and participated in the nation's war effort by working for the newly established 'A.V.G' and collecting recyclable waste in Braunschweig. Buchler's images affirm community and offer evidence of duty and collective belonging. While there were food riots in several German cities in 1915 and 1916, the children in Buchler's photographs do not look undernourished. Perhaps they were not (yet) affected by the outbreaks of TB, typhoid, dysentery, anaemia and rickets, which blighted many children's lives.[6] Catherine Rollet has rightly advised historians to be 'diffident' when considering the emotional impact of war on children as there is very little direct material.[7] The children's facial expressions offer no evidence of emotional turmoil and it is impossible to judge the extent to which working to defeat the enemy was internalised as children demonstrated their obligation to the state, but we do know that some of the boys in Buchler's photographs will, 25 years later, have become men carrying weapons rather than recycled waste, while others may have been identified as a threat to the state by National Socialists.

All three images are elaborately staged, yet at the same time look natural. There is an intimacy between Buchler and her subjects.

Image 4. A healthy, rosy-cheeked young girl in a pristine blue-and-white checked dress is captured deep in concentration as she works on the land during harvest time. Her hair is neatly plaited into a pony tail. She is placed at the centre of the image and its horizontal bands of colour. The blue lines of her dress compliment the blueness of the hills beyond and the blue of the sky. The image is diagonally dissected by her rake. Behind her a field waiting to be harvested stretches into the distance and the woodland beyond.

Taken in the Harz Mountains not far from Braunschweig in the 1920s, we have moved from a time of war to an apparent period of peace, from an interpretation of the world in terms of grey scale to that of colour. Buchler's use of Autochrome lends the image a luminous quality. It is an image of an innocent world untouched by politics and conflict, an image which recalls the idyllic family life of her pre-war work.

Käthe Buchler's photographs carry the weight of the eyewitness, a desire to remember or to remind others of everyday life in Braunschweig during this time of conflict, but it was a selective process. Her photographic eye reflects her life – quiet, domestic, bourgeois and intimate. Her wartime images of children, while rich in documentary content, do not reveal a sense of trauma, fear or desperation. Her images project the innocence of childhood and protect children from the realities of conflict.

Dr Nicola Gauld is Coordinator of the *Voices of War and Peace* Centre, based at the University of Birmingham, and co-curator of the *Beyond the Battlefields* exhibition. She has worked on a number of exhibitions and history projects and will soon publish a book on the Birmingham suffrage campaign.

Professor Ian Grosvenor is Director of the *Voices of War and Peace* Centre and Professor of Urban Educational History at the University of Birmingham.

6 Ludewig, Hans-Ulrich 'Braunschweig im Ersten Weltkrieg' in Ebner, Florian and Meinold, Jasmin (eds.) *Käthe Buchler Fotografien Zwischen Idyll und Heimatfront* (Braunschweig: Museum fur Photographie, 2012), pp 158–165
7 Rollet, Catherine 'The Home and Family life' in Winter, Jay and Robert, Jean-Louis (eds), *Capital Cities at War. Volume 2: A Cultural History*, Cambridge, 2007, p345

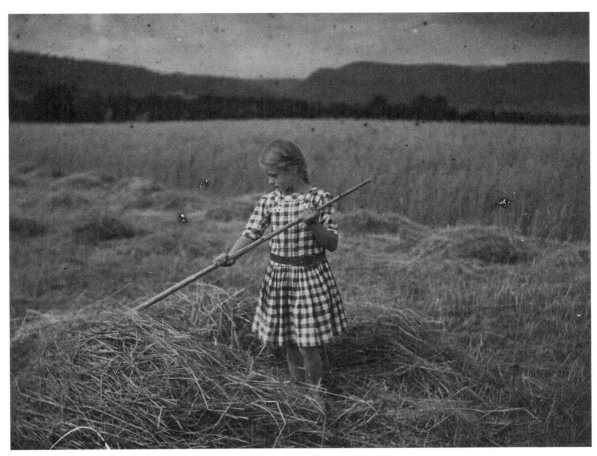

Image 4.
Farm girl in the Harz Mountains, 1927
Centre Pages: *Scene from a Fairytale*
(The Seven Kids – undated)

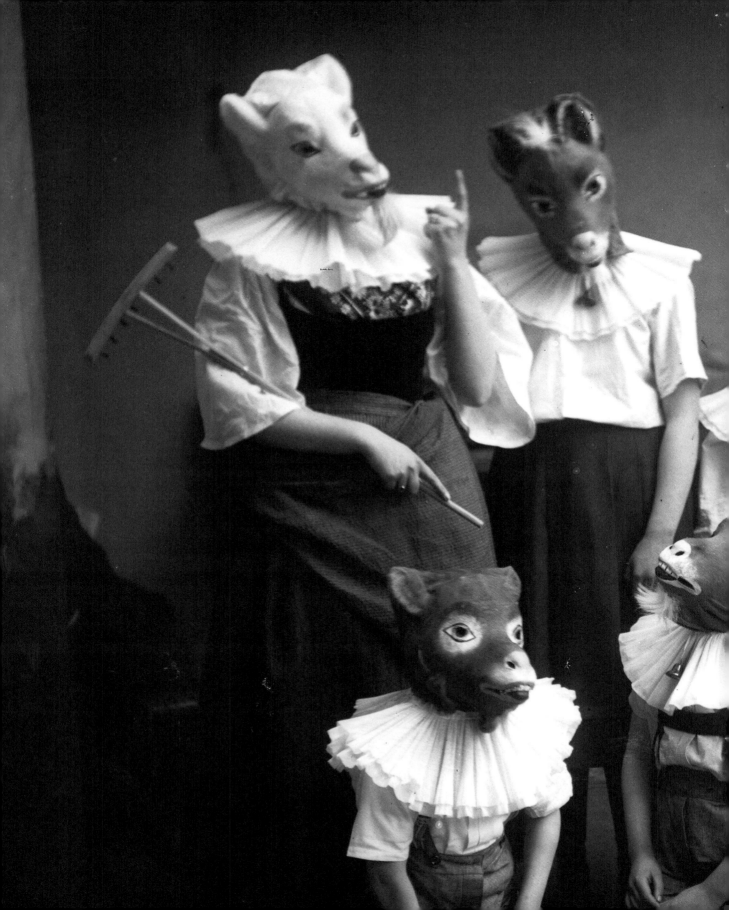

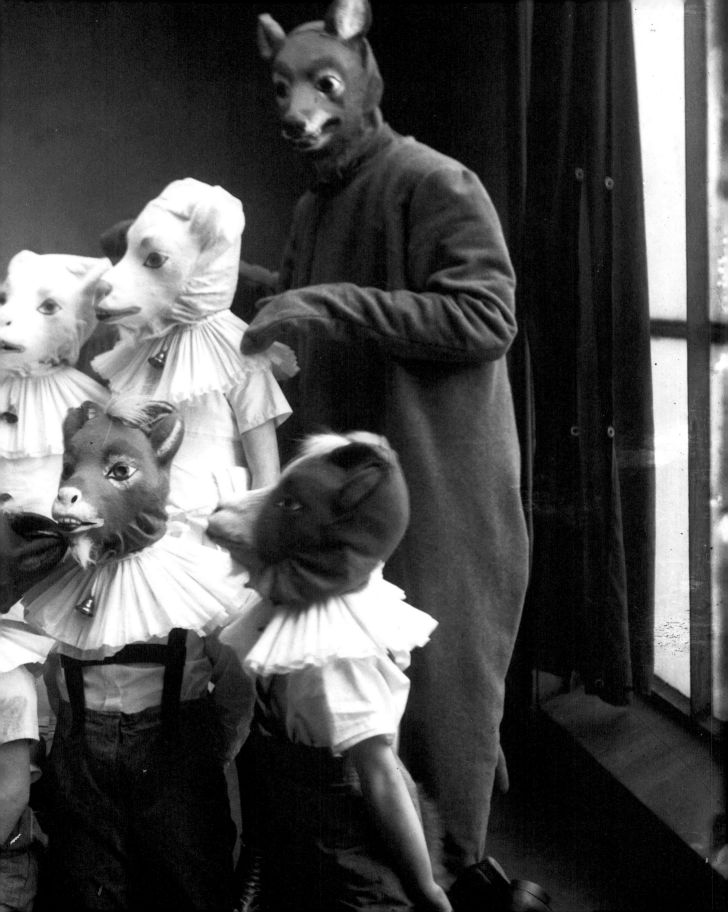

Responses:

The following pages feature a series of responses to individual images in the exhibition. These have been written by community partners from across the UK who have been working on First World War projects funded by the Heritage Lottery Fund and have collaborated with the *Everyday Lives* and *Voices* Centres. Each response offers a nuanced and diverse interpretation of Käthe Buchler's photographs and, more generally, seeks to broaden our approach to the lived experience of war.

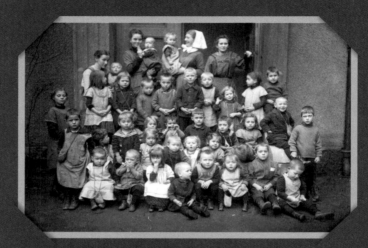

Children and their Carers – War Nursery (undated)

To me this photo looks like a war nursery. The building itself doesn't look very child-friendly but by the way that the children are dressed in clean clothes and looking quite healthy, I'd say that the staff were good Samaritans, and cared for the kids. If I was to talk to the children in the photo, I'd ask 'How do you think this nursery has helped make you who you are?' This photo makes me feel quite happy knowing that there was at least something out there for kids during the war. It has almost given me a sense of closure knowing that not every kid was left alone and that someone was out there caring for them.

Caitlin Dobbie is a 16-year-old researcher working with *Investing In Children World War One*. Investing in Children is a children's human rights project based in the North East of England. Their Heritage Lottery Funded project, *World War 1 – Who Cared for Kids?*, explored what happened to children who lost parents or who needed to be cared for because they were unsafe or unwell.

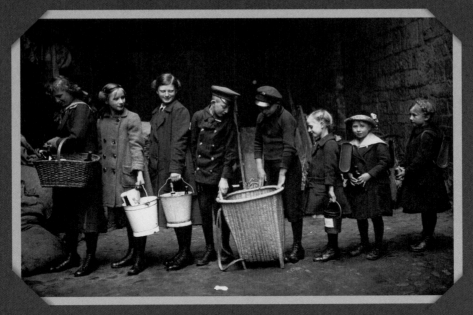

Children Queuing to Deliver Glass Bottles for Recycling c.1915

I wonder why the children are queuing? Are they lined up to give or have they just received? Dressed for the weather with coats buttoned, thick tights and socks, shiny shoes, hair neatly plaited, pinned or cut. I am curious of the task in hand. Each child has a means to carry; woven basket, enamel bucket, lidded tin and rucksack. There are bottles of various sizes, the buckets well loaded, the girls' arms pulled, hands tight on the handles. A suggestion of a paper bag or packet too. However it's the large basket in the centre that is causing the most interest, both to me and the children. Two boys proudly hold it lightly, at the handle and rim. A sturdy basket for a heavy load, it stands on four wooden feet protruding from the body of the basket. Two strong straps resting from their burden. The faces of the girls standing on either side show signs of knowing, mixed with pride and envy. I wonder which boy has borne the task of carrying the basket, for it surely is an important one. Perhaps they took it in turns. But, the question remains: What is in the basket?

Mary Crabb is a contemporary textile and basket maker, tutor and maths support teacher. She is part of the *Basketry Then and Now* community group. Their project has researched the importance of basketry and willow to the economic, social and cultural fabric of Britain during the First World War, and explored long-term legacies of the conflict in relation to intangible cultural heritage and landscape change.

(*Like other community respondents Mary Crabb wrote her response to the image above before she was made aware of Buchler's title for the photograph)

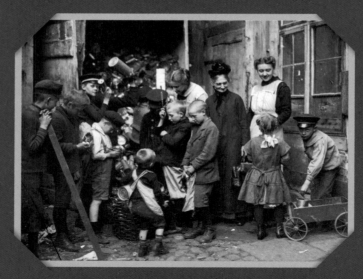

Women and Children Collecting Recyclable Waste, Braunschweig (Egg Market)1915

Whilst looking at this picture of a group of women and children in front of a pile of scrap metal that they collected in big woven baskets and small wooden carts, it seems to me that the photograph has turned these people into objects themselves: the penetrative stare of the young boy in the military-style cap, the smile of the woman in the apron - both forever fixed on their faces, and returned by myself more than a century later. They are part of a world that is no longer and yet, here they are, staring at me, smiling, tin cans for recycling to keep the cogs of the war industry going. They are unaware of the world from which I look at them - a place characterised by choice and material excess, a 'throw-away society' in which we risk being suffocated by 'stuff', which places our planet and all the species that inhabit it in serious peril. As I walk past over-flowing bins on my way to work, my mind often returns to the photograph of the pile of empty cans and I cannot help but think that today we are fighting a different kind of collective battle: no longer recycling to destroy the world, we are now racing to save it from destruction.

Esther Breithoff's award-winning PhD research explored the entangled relationships between humans and nature within a conflict and post-conflict setting. She is currently Research Associate with the Arts and Humanities Research Council project, Heritage Futures, at University College London.

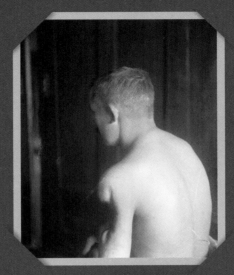

Study of a Serious War Wound c.1914–15

Distance Lends the Past a Fictional Glamour.

Disabled bodies in the present are often images of absence, of deficit. An empty wheelchair, the paint-peeled corridors of an abandoned asylum, ransacked filing cabinets and their scattered contents.

Look at the photographs of a century ago and the opposite happens. Stories crowd and jostle, rushing to fill the gaps and voids in what we think we know about these people. Narratives are created. Tragedy. Bravery. Unendurable suffering. Admirable stoicism. We join the dots, one, two, three, and put the puzzle back together.

And what we construct is sometimes beautiful: light shines, luminescent, on an arched back, on those impassive faces, simultaneously giving them the pallor of angels and the erotic thrill of St. Sebastian's martyrdom.
These people are dead. They cannot not see us, and they do not judge. But we permit ourselves to see and judge and make them into anything we want. So, that which repulses in the here and now, the puckered scars and scraped raw skin, assumes a different quality when it is viewed in comforting retrospect.

We are a hundred years away, long enough to feel safe. We won't ever have to meet them and pretend we aren't looking.

Sasha Callaghan is the Chair of *Disability History Scotland*, based in Edinburgh. Their Heritage Lottery Funded project *One Last Push* explored disability in the aftermath of the First World War and the struggle for a fairer society. Their current project, *Justice not Charity, Was their Cry,* uncovers the history of the National League of the Blind march in 1920.

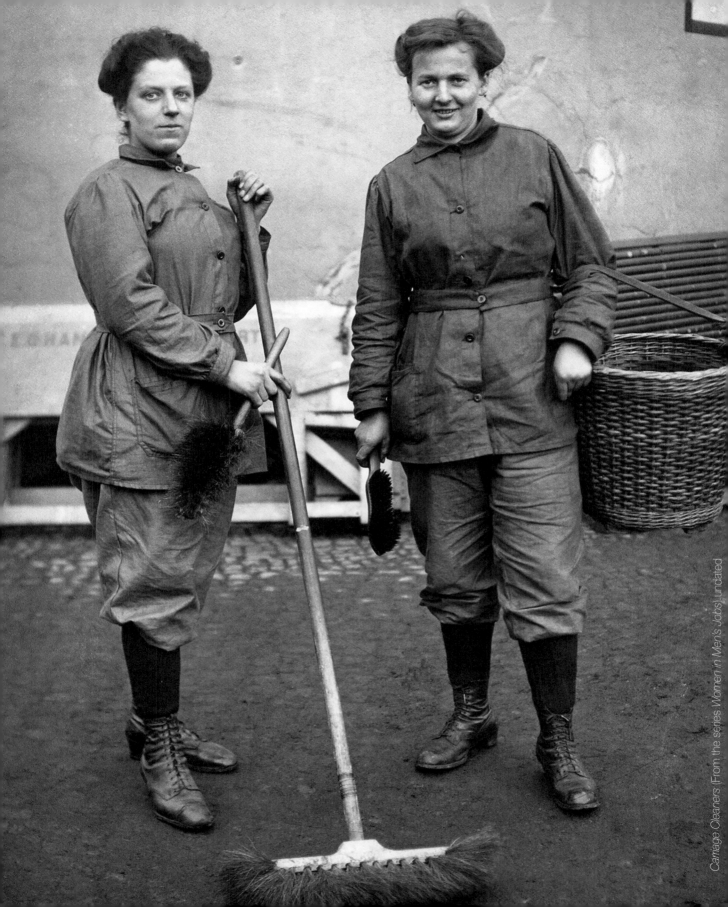

Love Letter to a Carriage Cleaner from a Modern Day Dyke

You on the left...the one with the broom. I'm going to take the liberty of
calling you Ilse. You look...magnificent, statuesque and proud. Your bearing is
strong, your stance, balanced and poised. Your gaze is speaking to me across
the decades from your space and time where being photographed in men's attire
with a girl by your side is what's called for. There's nothing new here. Women
have wielded tools since they first invented them. They've exchanged glances and
smiles and tears and love and meaning forever.

It's new to be captured on film. Yes. That's new and Berta on the right, you're
curious and just a little bit caught off guard - your balance slightly more on
the back foot, your expression a little unsure. Smiling but unsure.
Getting back to Ilse... my dear you totally rock the leather and oilskin look
and, can I just say the suggestive way you've poised your bog brush in front of
your pussy is divine. Or was that a Käthe touch? Either way it totally works
for me. You grasp the handle in your right hand and steady the long pole of the
broom between your agile second and middle fingers. Your left hand fingers the
broom end and pushes the brush forward to dominate the image bottom centre.

Yes it's about the work. And there's a war on. And I shouldn't objectify you for
my own delectation or to get a laugh because we absolutely cannot know if you'd
consent to that. Probably not. But maybe, maybe you'll dance in an all-queer
Berlin bar in ten years time and Otto Dix will paint you and you'll be happy.
After that, sadly, no one's going to give you the option to be taken seriously
as a lesbian in your lifetime. It will get very bad. So allow me, anyone
making your own judgements, and Ilse, allow me just this moment to share the
possibilities by returning your gaze.

Ali Child and **Rosie Wakley** run their own theatre company, Behind the Lines. Their shows include *All the Nice Girls*, which champions lesbian variety stars Gwen Farrar and Norah Blaney who met while entertaining troops during the First World War. With support from the Heritage Lottery Fund and Arts Council England, *All the Nice Girls* has toured extensively, including performances at the Edinburgh and Brighton Fringe festivals.

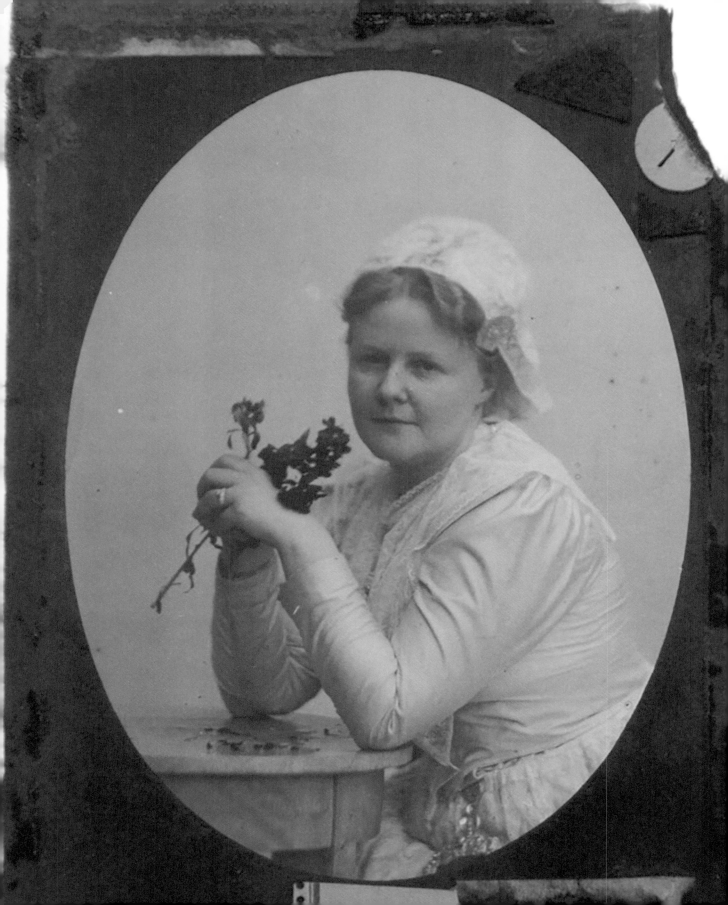

Käthe Buchler in the Weimar Republic

Helen Boak

In 1920 Käthe Buchler produced a self-portrait in her beloved Autochrome. Framed as a miniature, the photograph reveals a respectable, middle-aged, upper-middle-class housewife, wearing a delicate mob cap and chatelaine, sitting at a table holding a couple of flower stems.[1] This photograph is markedly different in purpose, style and composition to the black-and-white self-portraits of a younger generation of women photographers who came to prominence in the 1920s during the brief flowering of Weimar Germany's creativity. For these women, a self-portrait (often using a mirror) was not conceived as a true likeness but as a reflection of their position as autonomous independent women and skilled practitioners in the emerging landscape of women's photography.

In a mid-1920s self-portrait (*Self Portrait with Cigarette*, 1925) Germaine Krull has pictured herself looking through the lens of her Icarette camera. The focus is very much on the camera held in both hands, a lighted cigarette held loosely between two fingers of one hand, with Krull's face part of a blurred background. Again using a mirror, in a 1933 erotic self-portrait, another photographer, Marianne Breslauer, seems to revel in her photographic ability, imaging herself with a camera and tripod, the cord release in her hand, her face obscured by the wedge of her hair and her dressing gown open to reveal her naked body.[2] While in 1930 Gertrud Arndt used her series of 43 masked self-portraits to question women's identity, through appearing in a variety of disguises.[3]

Left: Self Portrait, c1920

Krull, Breslauer and Arndt all share the characteristics of the 'New Woman'; they were young, urban, economically independent, with fashionable clothes and hairstyles, and in a position to take advantage of all the opportunities the newly established Weimar Republic offered them.[4] Where Buchler presented an intimate world, whose coordinates were her family life and her wider social and philanthropic associations set against the enduring certainties of Wilhelmine German life, the engaged, media-savvy and independent 'New Woman' of Weimar Germany was increasingly both the producer and the subject of photography, producing some of the signature images of interwar commerce, advertising and art using techniques such as photograms, photomontage, multiple exposures, and extreme close-ups, as the female consumer was targeted by the press and advertisers. Thanks in part to new technological advances in photography and printing, Weimar's female photographers were also able to turn the camera on themselves.

Remarkably, given its innovative and experimental characteristics, much of the pioneering work of women photographers in the Weimar Republic languished in obscurity until, in 1994, the Folkwang Museum in Essen brought the works of 53 women who worked as photographers in the Weimar Republic to public attention (*Fotografieren Hieß Teilnehmen – Fotografinnen der Weimarer Republik* – Taking Photographs Meant Taking Part – Women Photographers of the Weimar Republic 16.10.1994 – 08.01.1995).[5] Although women had worked in photography from the 1840s and had been able to access training in the graphic techniques and practical applications of photography from 1890 when the Lette Academy had opened its photography school, their numbers increased exponentially in the 1920s.[6]

[1] Jung, Miriam & Schmidt, Franziska (eds), *Die Welt in Farbe – Käthe Buchler Autochrome* 1913–1930, Appelhans Verlag, Braunschweig, 2012 (2nd edition) p1.
[2] Molderings, Herbert & Mülhens-Molderings, Barbara, 'Mirrors, Masks and Spaces. Self-portraits by Women Photographers in the Twenties and Thirties', in Fabre, Gladys (ed.), *La dona, metamorfosi de la modernitat,* Fundació Joan Miró, Barcelona, 2004 pp 29–65, 320–25.
[3] http://www.anothermag.com/art-photography/8976/the-many-disguises-of-bauhaus-photographer-gertrud-arndt, accessed 19 December 2017.
[4] For these opportunities, see Boak, Helen, *Women in the Weimar Republic,* Manchester University Press, Manchester, 2013.
[5] Eskildsen, Ute, 'A chance to participate: A transitional time for women photographers', in Meskimmon, Marsha & West, Shearer (eds), *Visions of the "Neue Frau": Women and the Visual Arts in Weimar Germany,* Scholar Press, Aldershot, 1995 pp 62–76.
[6] Ibid, p63.

In 1919, 337 women were enrolled in photography courses at the Lette Academy.[7] Women could also take photography courses at colleges in Berlin and Munich, while others undertook a three-year apprenticeship with a photographer. Some came to photography through the, at the time unexpected, route of their art school training. Gertrud Arndt, for example, took a photography seminar with the Hungarian photographic luminary Laszlo Moholy-Nagy during her foundation year in weaving studies at the Bauhaus.[8] Suffice to say that by 1931 over 100 photographic studios in Berlin alone were owned and run by women.[9] Mostly from urban, middle-class, backgrounds, they were well-educated and many were Jewish.[10]

The large number of Jews amongst this group of female professional photographers may account for the relative invisibility of their work in the art-historical narratives that were written in both parts of Germany and internationally after the Second World War. Many fled Germany after 1933, had their work destroyed by the Nazis, or lost it in the displacement and destruction of combat, invasion and emigration.[11] After 1933, some like Ilse Bing, Lotte Jacobi and Ellen Auerbach continued their careers in the United States of America, while others such as Breslauer and Arndt gave up photography. Many had been consummately international: photographers like Bing, Breslauer and Annelise Kretschmer, being from wealthy backgrounds, were able to travel to Paris in the 1920s and access the vital cosmopolitan debates around art, aesthetics and the place of photography within them that were a by-product of France's own inter-war social and political instability.

For her part, Germaine Krull travelled throughout Europe, producing *Métal*, a portfolio of 64 industrial landscapes, in 1928. Widely considered to be one of the most important photographic publications of the 1920s, *Métal* eschews interpretive texts and employs 'expressionistic' camera angles and close-ups recalling the pioneering work of Bauhaus photographers like Moholgy-Nagy or Soviet Constructivists like Aleksandr Rodchenko. Krull was one of several women whose work was exhibited at the 1929 international *Film und Foto* exhibition in Stuttgart. Organised by the Deutscher Werkbund, *Film und Foto* was one of a number of exhibitions which toured Germany toward the end of the Weimar Republic, and posed searching questions around what photography was and how it might develop.[12]

The introduction of the small, lightweight 35mm Leica camera in 1925, along with technical improvements which included higher shutter speeds, interchangeable lenses and the ability to take photographs in varied light conditions, as well as advances in print technology, led to an explosion in the demand for commercial photography by the print media and advertisers in the later 1920s. By 1931 there were 7303 different newspapers and magazines available across Germany and photographs became an increasingly dominant visual device initially to illustrate an article and communicate ideas, but increasingly also to tell the story. Photojournalism flourished, and noted female photojournalists included Krull, Jacobi, Kretschmer, Lotte Errell, Alice Lex-Nerlinger and Else Neuländer-Simon, better known as Yva, a leading fashion photographer who, as a Jew, was no longer able to work as a professional photographer after 1938.[13]

[7] March, John, *Women Exile Photographers*, in Brinson, Charmian, Buresova, Jana Barbora & Hammel, Andrea (eds), *Exile and Gender* II. *Politics, Education and the Arts*, Brill, Leiden, 2017 p135.
[8] Eskildsen, *op. cit.*, p66.
[9] Ganeva, Mila, *Fashion Photography and Women's Modernity in Weimar Germany, The Case of Yva*, NWSA Journal, 15:3, 2003 pp 1–25.
[10] Eskildsen, *op. cit.*, pp 65–6.
[11] Hagen claims that nearly half of the photographers in the Essen exhibition were Jewish: Hagen, Charles, *Photography Review; Women of the Weimar Era, in a Social Context*, The New York Times, 28 April, 1995.

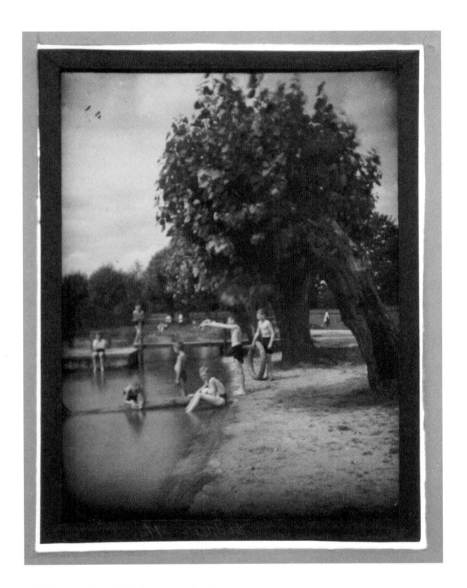

Bathing Beach, City Park, Braunschweig c. 1930

12 Holland, Claire, *In plain sight: Germaine Krull in Paris*, Financial Times, 13 June, 2015; *The Thomas Walther Collection* 1909–1949. An Online Project of
 The Museum of Modern Art, New York: The Museum of Modern Art, 2014. http://www.moma.org/interactives/objectphoto/assets/essays/Lugon.pdf.
13 On Yva, see Ganeva, *op. cit.*. She is believed to have been killed in Majdanek in 1942.

Professional female photographers could earn their living both inside and outside the studio, taking portraits, producing photographs for use in the press or advertising, or as political propaganda. Grete Stern and Ellen Auerbach set up *ringl+pit* in 1930, specialising in photography for advertising, while Jacobi's portrait of Communist Party leader Ernst Thälmann was used in the 1932 Presidential election campaign.[14] Older than, and something of a shrinking violet by comparison with, the shock troops of Weimar women's photography, we see no such experimentation in Käthe Buchler's work of the inter-war period.

After the First World War Buchler, who was widowed in 1929, largely withdrew from public life and resumed taking photographs of her family and friends, at home, at leisure and on holiday. She also continued to produce beautifully composed colour still lives and landscapes producing a single series of architectural photographs of 'quiet corners in Brunswick' which was published in 1929. She continued to present illustrated slide lectures, with the proceeds going to the charities she supported.[15]

While younger, metropolitan female photographers were documenting the life of the 'New Woman' or industrial complexes, Buchler's photographs offer unfamiliar and unexpected, even exotic insights into the private lives of Weimar Germany's upper-middle class and the continuities of rural life in the 1920s until 1930. The working women she photographs are domestic servants and agricultural workers, areas of declining significance for women's employment. We learn nothing from her photographs of the political and economic turmoil in Braunschweig or of the changes in society during the Weimar period.

The Buchler family seems to have come largely unscathed through the economic crises of the post-war era, the hyper-inflation culminating in 1923, and the mass unemployment of the Great Depression from 1929. Yet Buchler was clearly politically aware: she died of heart failure aged 53 on 14 September 1930, having left her private hospital bed where she had been confined having broken her ankle to cast her vote in the state and national elections.[16] There are claims that she went to vote against Hitler's Nazi Party, which had been winning seats in state parliaments since 1929 and was extremely active in Braunschweig.[17] If so, she acted in vain, as the Nazis polled their second highest share of the vote throughout Germany in Braunschweig and were strong enough to enter a coalition government in the state parliament.[18]

It is perhaps her upright steadiness that both defines what we know of Käthe Buchler, but perhaps also obscures an understanding of her true essence and potential as a photographer and perhaps more widely as a citizen. Her life and her position in society were substantially patterned by the social coordinates of Wilhelmine Germany and her obligations as a wife and mother. She was never a 'professional' photographer; neither was she anything approaching the 'New Woman' of Weimar Germany. She did, however, possess a quite singular photographic vision the development of which was cut short by her untimely death in 1930. Nearly one hundred years later, Käthe Buchler is justifiably receiving recognition both for the documentary insight her photographs offer of the home front in First World War Braunschweig, and for the technical prowess and artist's eye which resonate from her beautifully composed, luminous Autochromes, reminiscent of nineteenth-century paintings.

Dr Helen Boak was, until her retirement, Head of History at the University of Hertfordshire. She has written numerous essays on the history of women in early-twentieth-century Germany and is the author of *Women in the Weimar Republic* (Manchester University Press, 2013).

Opposite: Harvesters, 1928–1930

[14] Stern and Auerbach left Germany in 1933, Jacobi in 1935: March, *op. cit.* p137.

[15] *Stille Winkel aus Braunschweig, Braunschweigische Heimat*, 20:4, 1929 pp 137, 145, 150–2; Weber-Andreas, Karin, 'Drei Fotografinnen aus dem Lette-Verein', in Oberschernitzki, Doris & Weber-Andreas, Karin (eds), *Im Blick: Die Fotografin . . . aber was noch?*, Selbstverlag, Berlin, 1991 p21.

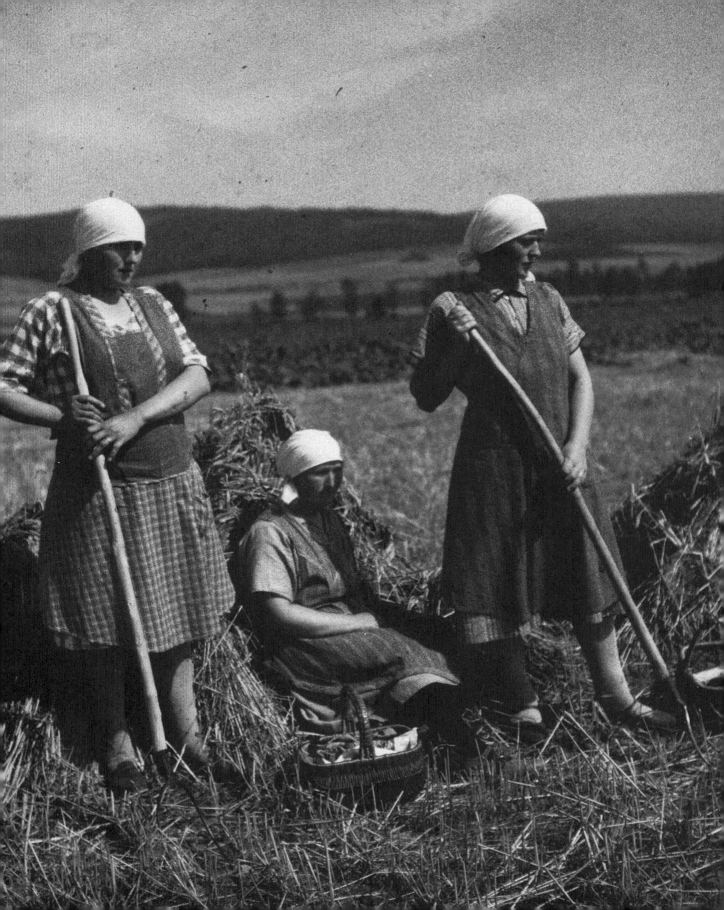

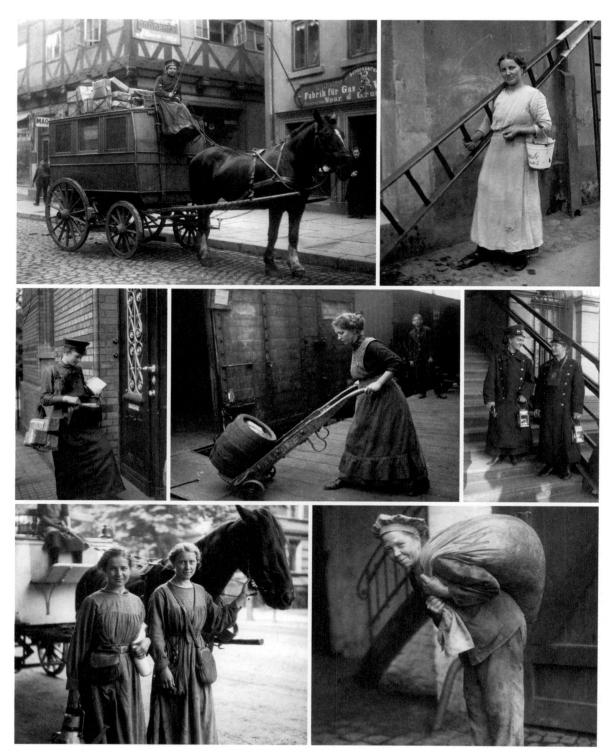

From the series *Women in Men's Jobs:*
Top left: *Stagecoach Driver,* 1917, Top right: *Window Cleaner* (undated),
Centre Left: *Postwoman* (undated), Centre: *Labourer* (undated), Centre Right: *Conductresses* (undated),
Bottom Left: *Milk Sellers* (undated), Bottom Right: *Carrier* (undated), Opposite: *Two Conductresses* (undated)

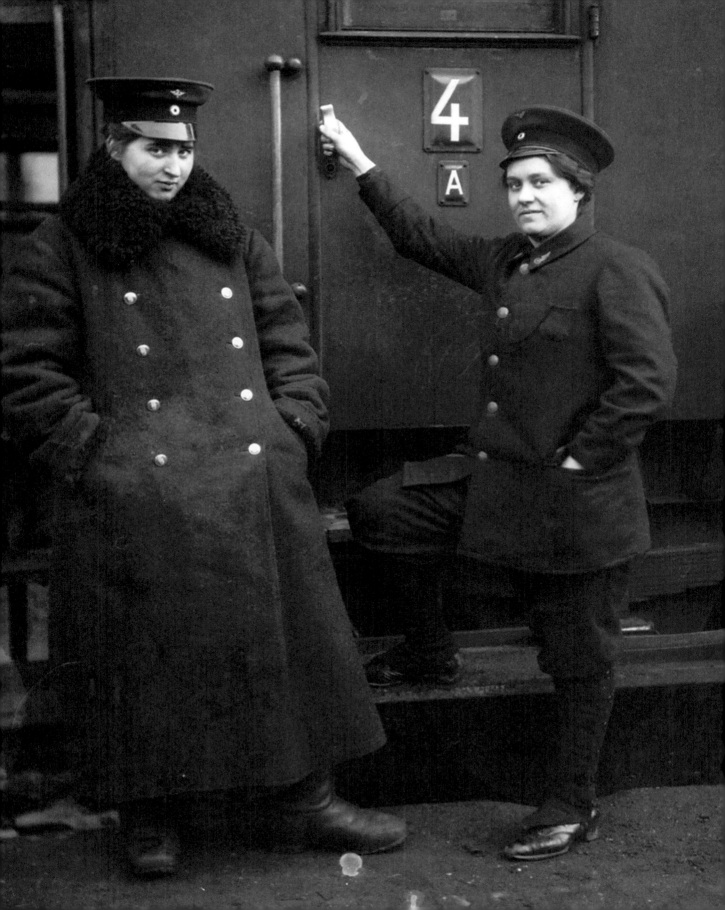

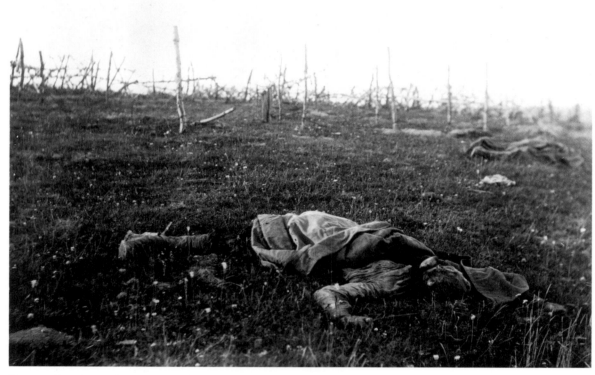

Florence Farmborough
Dead Russian soldier, photographed on the road to Monastyryska (Ukraine), 1916 © IWM (Q98431)

Käthe Buchler in Context: Women's Photographic Viewpoints on War in the Early Twentieth Century

Dr Pippa Oldfield

War photography is usually assumed to be something that is made on the battlefield by a risk-taking photojournalist alongside fighting soldiers. Not only is this a narrow conception of war photography, but it is also a mode that sidelines most women, who have historically been excluded from the military as well as discouraged from 'hard news' photography. As the remarkable work of Käthe Buchler demonstrates, however, women have been resourceful in finding alternative modes of photography to reflect their viewpoints on war.[1]

Buchler was a particularly skilled and committed image-maker, but she was by no means the only woman to make photographs in response to conflict at the beginning of the twentieth century. It was socially acceptable for women of the era to participate in certain fields of photography, and they made images in the capacity of professional photographers and casual snapshooters, as well as skilled amateurs (like Buchler). After the launch of the Kodak snapshot camera in 1888, photography became relatively cheap, easy and accessible, even to the unskilled. Women were encouraged to make personal photographs via handbooks, exhibitions, competitions, and magazine articles, and were particularly targeted by the famous 'Kodak Girl' advertising campaign.[2] This aspirational embodiment of the New Woman urged women to make images of 'places, […] people and incidents from your own point of view', encouraging photographs in which women's viewpoints were central.[3]

Convention dictated that women should focus on 'feminine' topics such as family, portraits, children, travel, and social events. However, in practice women's photography in the early twentieth century expanded these narrow bounds. A small number of professional photographers worked in the fields of press and news photography, and women's photo-albums contained snapshots that explored topics such as industry, medicine, immigration, and war.[4]

In the UK and the US, a small number of female professionals made images during the First World War. Christina Broom (1862–1939), an entrepreneurial London-based press photographer, was official photographer to the Brigade of Guards and Household Cavalry from 1904. Broom's photographs are relatively free of the jingoism of the era, perhaps due to her close personal connections with soldiers.[5] She made poignant images of British servicemen taking leave of their families at Waterloo Station in 1914, and subsequently made subdued records of crowds hearing the announcement of the Armistice in 1918. Remaining on the Home Front like Käthe Buchler, Broom also recorded the spectacle of women working in hitherto male professions, including a series of group portraits of the Women's Police Service and Volunteer Reserve Signallers.

Other women professionals travelled to the frontlines. Helen Johns Kirtland (1890–1979), a staffer for US magazine Leslie's Illustrated, covered news stories in

1 My thanks to the Paul Mellon Centre for Studies in British Art, and Peter E. Palmquist Memorial Fund for Historical Photographic Research, for their support of my research.
2 West, Nancy Martha Kodak and the Lens of Nostalgia, Charlottesville: University of Virginia, pp.109–135, 2000; John P., Jacob, ed. Kodak Girl: From the Martha Cooper Collection, Göttingen: Steidl, 2011
3 From an advertisement entitled 'The Kodak Story', which featured in the June 1907 edition of The Outing magazine, original emphasis.
4 Snyder, Stephanie 'The Vernacular Photo Album: Its Origins and Genius' in Barbara Levine and Stephanie Snyder (eds) Snapshot Chronicles: Inventing the American Photo Album, New York: Princeton Architectural Press, 2006 pp.25–33.
5 Roberts, Hilary British Women Photographers of the First World War, www.iwm.org.uk, 2014; Anna Sparham (2015) Soldiers and Suffragettes: The Photography of Christina Broom London: Philip Wilson /Museum of London. Broom's images are held by the Museum of London and IWM (Imperial War Museums).

the European theatre of war including the retreat of Italy after the Battle of Caporetto in 1917, as well as gender-specific stories such as 'A Woman on the Battle Front'. She was one of the very few women allowed into the famous Hall of Mirrors in Paris to witness the German delegation signing the Treaty of Versailles in 1919. Despite these high-profile assignments, Johns Kirtland is little known today.[6]

One of the most important records of women's war work was made by Olive Edis (1876–1955).[7] A successful British portrait photographer with a list of celebrity clients including Prime Minister David Lloyd George, Edis was selected by the Women's Work Subcommittee of the Imperial War Museum to document women's auxiliary services at the Western Front. Edis's images, made during an arduous month-long tour of Northern France and Flanders in early 1919, are often beautifully illuminated by natural light. Like Buchler, she used a glass-plate camera to produce large-scale negatives and high quality images, many of which have now been digitised by the Imperial War Museum and are available to see online. Edis had an excellent eye for composition, especially given the rushed conditions in which she worked, often developing her plates in the x-ray units of hospitals. Like Buchler's *Women in Men's Jobs* – see pages 42 and 43, Edis's images show women assuming masculine positions — repairing aircraft or driving ambulances — at a transitional point when female roles were expanding to free up men for combat service.

Many more women made photographs of their wartime experiences in an independent capacity. One of the most notable is Florence Farmborough (1887–1978), a British governess in Russia who volunteered as a surgical nurse for the Russian Red Cross.[8] Like Buchler, Farmborough was a keen amateur in the true sense of the word: an unpaid but skilled and aesthetically ambitious photographer. Her glass-plate camera and tripod accompanied her throughout her wartime experiences, until the Bolshevik Revolution of 1917 forced her to return home. Operating far from the scrutiny of press

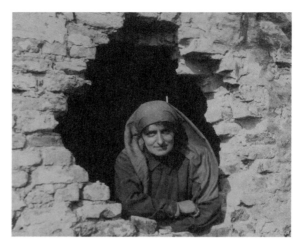

Mairi Chisholm
Elsie Knocker by Mairi Chisholm
Reproduced by Permission of the National Library of Scotland

restrictions at the Western Front, Farmborough made some of the most haunting records of the First World War, including an unforgettable image of a Russian soldier lying dead on the battlefield, taken en route to *Monastyryska* in present-day Ukraine.

The Scottish teenager Mairi Chisholm (1896–1981) photographed her intense life under fire while working as a nurse and ambulance driver at a First Aid post in Pervyse, West Belgium.[9] Chisholm used, among other cameras, a Kodak Vest Pocket: a snapshot model explicitly marketed to men as 'The Soldier's Camera'. In practice, however, numerous women used this model as well. Chisholm seems to have made photographs primarily in a documentary rather than artistic capacity. Despite being untrained many of her images are dramatically composed, such as a portrait of her co-worker Elsie Knocker peering through a bombed wall. Chisholm's photo albums, held in the National Library of Scotland, feature a startling range of images. Veering from humorous and domestic to graphic and disturbing, the albums reflect the incongruities of her precarious existence at the front.

[6] There is very little scholarship on Helen Johns Kirtland. For a biography by the Library of Congress, see 'Helen Johns Kirtland', www.loc.gov.
[7] Murphy, Alistair & Elmore, Elizabeth *Fishermen and Kings: The Photography of Olive Edis* Norwich: Norfolk Museums Service, 2016
[8] Joliffe, John (ed.) *Florence Farmborough: Russian Album* 1908–1918. Copies of Farmborough's prints can be found in the IWM (Imperial War Museums) and The Brotherton Library at University of Leeds, 1978
[9] Atkinson, Diane *Mairi and Elsie Go To War: Two Extraordinary Women at the Western Front* Cambridge: Pegasus, 2010
[10] New Focus (eds.) *No Man's Land: Young People Uncover Women's Viewpoints on the First World War* Bradford: Impressions Gallery.

Other women had less notable war careers than Chisholm and Farmborough, but nonetheless compiled arresting photo-narratives of their experiences. A number of collections and albums of 'ordinary' women were gathered by the historian Peter Liddle and are conserved in the Brotherton Library at the University of Leeds. Mary 'Fluffy' Porter, who served in the British WAAF (Women's Auxiliary Air Force), made and collected photographs of her time at RAF Blandford in Dorset, southwest England. Her album pages juxtapose snapshots of friends with official portraits of uniformed colleagues and views of military aircraft. Sister Sara 'Josie' Kane who served as a nurse in Malta, compiled images in a mass-produced album decorated with floral emblems.[10] Filled with snapshots of her wartime work, including a startling image of nurses with a patient captioned 'Gunner Baldwin whose legs and arms were off', Kane's albums are a collision of masculine and feminine pictorial conventions.

Women's early photography in response to conflict is not restricted to the First World War. The concurrent Mexican Revolution (1910–1920), although overlooked by most historians of war photography, was arguably the first major conflict to be depicted on a mass scale. A number of women were among the throng of freelancers from the US that witnessed the Battle of Ciudad Juárez in 1911, when the charismatic rebel General Francisco 'Pancho' Villa routed the federal forces. Women who crossed the border at El Paso to photograph the battle included *Harper's* reporter Edith Lane, El Paso studio worker Eva Esther Strauss, and amateurs Clara Goodman and Calla Eylar.[11] Jacqueline Dalman, a snapshooter who happened to be in Ciudad Juárez celebrating her engagement in May 1911, made a day-by-day record as the city fell to rebel troops. Dalman's breathless commentary, not all of it strictly accurate, is scrawled on the photographs in red ink, and conveys a vivid impression of civilians caught up in the confusion of the combat zone.[12]

Sister Kane
Special Collections, Leeds University Library

Reproduced with the permission of Special Collections, Leeds University Library and Estate of Sister Kane (LIDDLE/WW1/WO/o6o)

Other women were able to make more considered records. The American Kate Leach (1882–1972) was living in Ciudad Madera, in Chihuahua, northwest Mexico, during the Revolution. Using a snapshot camera, she recorded troops passing through the town and her family's encounter with a train carrying a rebel payload. With an eye to posterity, Leach later assembled a pair of photo-albums, integrating her own snapshots of the Revolution with commercially available views of battle and military personnel, alongside pictures of her family and young children.[13] Her albums echo the advice of the Kodak Girl advertisements – to photograph places, people and incidents from a woman's viewpoint – but their politicised content could hardly be more different from Kodak's anodyne marketing images of motor-trips and seaside jaunts.

[11] Berumen, Miguel and Canales, Claudia (eds.) *Mexico: Fotografía y Revolución* Mexico City: Fundación Televisa y Lunwerg, 2009 pp.382–389
[12] Conserved in the El Paso Historical Society, Texas.
[13] Conserved in the Harry Ransom Center, University of Texas at Austin.

The most extensive body of work to record the Revolution was made by Sara Castrejón. A Mexican professional photographer, Castrejón owned a portrait studio in Teloloapan, a small town in Guerrero, southwest Mexico.[14] By necessity, she became a semi-official photographer to the occupying forces, producing studio portraits of military personnel, equestrian studies, records of soldiers' manoeuvres, the signing of treaties, military funerals and troop encampments. She was even called upon to make records of prisoners prior to execution by firing squad and on at least one occasion actually recorded the moment of death itself. Subsequently, Castrejón largely reverted to her pre-war practice of family portraits, weddings and christenings, but she bequeathed a remarkable record of the Mexican Revolution.

There are many more instances of women using photography to comment upon war in Buchler's era, and this brief discussion has only highlighted a handful. One of the challenges to research is that women's photography has often been undertaken in a personal capacity, and largely remains outside official histories and public collections. There is still much to learn, but the swell of projects both curatorial and academic is helping to present a clearer picture of women's photography in response to war.[15]

The work of Buchler and her historical counterparts is invaluable in providing us with a greater insight into women's experiences of war. Although diverse in their motivations, each of these female photographers demonstrates a sense of historical consciousness and a determination to register herself at the centre of events. It is no small achievement that these women should have claimed the authority to comment on war and politics, despite not having the vote. Collectively, the images by Buchler and her peers have bequeathed us with a richer and more nuanced understanding of war in the early twentieth century. Their work demonstrates that war photography can be an incredibly broad endeavour, made by anyone who has something to say on the subject of war.

Dr Pippa Oldfield is Head of Programme at Impressions Gallery, Bradford and an honorary research fellow at Durham University

[14] Samuel F. Villela (2010) Sara Castrejón: *Fotógrafa de la Revolución Mexico City*: Instituto Nacional de Antropología e Historia
[15] Recent contributions include the exhibitions *No Man's Land: Women's Photography and the First World War*, curated by Pippa Oldfield, Impressions Gallery, Bradford, UK, 7 October to 30 December 2017; and *Kriegsfotografinnen in Europa*, 1914–1945, curated by Marion Beckers and Elisabeth Moortgat, Das Verborgene Museum, Berlin, 28 September 2017 to 25 March 2018.

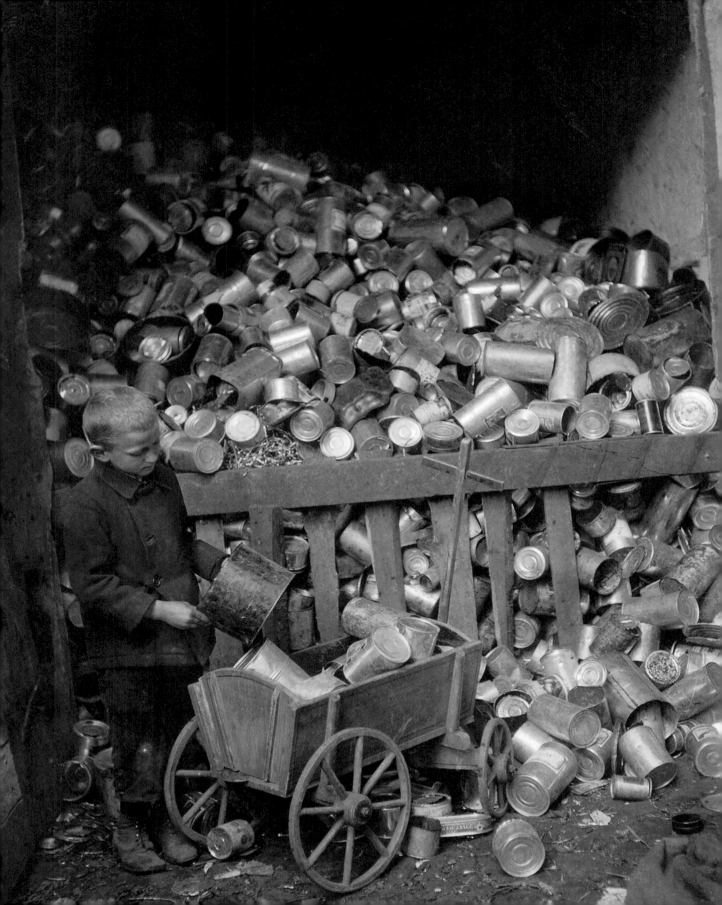

Select Bibliography

Atkinson, Diane *Mairi and Elsie Go To War: Two Extraordinary Women at the Western Front,* Cambridge: Pegasus, 2010

Berumen, Miguel and Canales, Claudia (eds.) *Mexico: Fotografía y Revolución* Mexico City: Fundación Televisa y Lunwerg, 2009

Boak, Helen*, Women in the Weimar Republic,* Manchester University Press, Manchester, 2013.

Dyer, Geoff (ed.) *John Berger Understanding a Photograph* London: Penguin Books 2013

Evans, J. (ed.) *The Camerawork Essays. Context and Meaning in Photographs,* London: Rivers Oram Press, 1997

Ebner, Florian & Meinhold, Jasmin (eds) *Käthe Buchler – Fotografien Zwischen Idyll und Heimatfront* Museum für Photographie Braunschweig, 2012

Jackson, Bruce : *Full Colour Depression, First Kodakchromes from America's Heartland*, Centre Working Papers, SUNY, Buffalo, 2011

Jung, Miriam & Schmidt, Franziska (eds), *Die Welt in Farbe – Käthe Buchler Autochrome* 1913–1930, Appelhans Verlag, Braunschweig, 2012

Winter, Jay and Robert, Jean-Louis *Capital Cities at War. Volume 2: A Cultural History*, Cambridge: Cambridge University Press, 2007

Levine, Barbara and Snyder, Stephanie (eds) *Snapshot Chronicles: Inventing the American Photo Album*, New York: Princeton Architectural Press, 2006

Meskimmon, Marsha & West, Shearer (eds), *Visions of the "Neue Frau": Women and the Visual Arts in Weimar Germany*, Scholar Press, Aldershot, 1995

Murphy, Alistair & Elmore, Elizabeth *Fishermen and Kings: The Photography of Olive Edis,* Norfolk Museums Service, Norwich, 2016

Roberts, Hilary *British Women Photographers of the First World War,* Imperial War Museum, 2014

Sachsse, Christoph & Tennstedt, Florian (eds) *Jahrbuch der Sozialarbeit* 4, Rowohlt Verlag, Hamburg 1981

Sparham, Anna *Soldiers and Suffragettes: The Photography of Christina Broom*, Philip Wilson / Museum of London 2015

Trachtenberg, Alan *The Group Portrait in Multiple Exposures*, Independent Curators Incorporated, New York, 1995

Tucker, A. Michaels, W. & Zelt. N. (eds), *WAR / PHOTOGRAPHY,* Museum of Fine Arts, Houston 2012

Villela, Samuel F. Sara Castrejón: *Fotógrafa de la Revolución*, Instituto Nacional de Antropología e Historia, Mexico City 2010

West, Nancy Martha *Kodak and the Lens of Nostalgia*, University of Virginia, Charlottesville, 2000

Published to accompany the touring exhibition Beyond the Battlefields – Käthe Buchler's Photographs of Germany in the Great War.

Co-organised by the University of Hertfordshire Galleries, the AHRC-funded First World War Engagement Centres at the Universities of Hertfordshire and Birmingham in collaboration with the Museum für Photographie Braunschweig and Departure Lounge

Exhibition Curator and Overall Project Organiser: Matthew Shaul, Departure Lounge (matthew@departure-lounge.org.uk)
Overall PR Coordination: Hazel Foxon, UH Galleries/Freelance

20 October 2017 -14 January 2018
Birmingham Museum and Art Gallery, Chamberlain Square, Birmingham B3 3DH
www.birminghammuseums.org/bmag
University of Birmingham, Edgbaston, Birmingham B15 2TT
www.birmingham.ac.uk
Voices of War and Peace First World War Engagement Centre, University of Birmingham
www.voicesofwarandpeace.org/
Centre Director: Professor Ian Grosvenor
Project Coordinator & Exhibition Curator (Birmingham Venues) Dr Nicola Gauld
Installation and coordination Birmingham Museum & Art Gallery: Katie Hall, Sophie Szynaka
Installation and coordination at Birmingham Museum & Art Gallery and UoB Research & Cultural Collections: Brigitte Winsor, Katie Hall, Sophie Szynaka, Clare Mullett, Jenny Lance, Nadia Awal, Clare Marlow, Rose Parkinson, Natalia Siemens

2 February - 3 March 2018
Grosvenor Gallery, Manchester Metropolitan University, Cavendish St, Manchester M15 6BR
www.holdengallery.mmu.ac.uk
Exhibition Curators and Project Coordination: Jacqueline Butler and Melanie Tebbutt
Curatorial consultant: David Brittain

17 March – 5 May 2018
Art and Design Gallery, University of Hertfordshire, College Lane, Hatfield AL10 9AB
www.uharts.co.uk
Director UH Arts: Annabel Lucas
Project Coordinator: (transport/loans/installation management/project development): Sammy Maitland
Exhibition Production: Asa Miller, Joe Fordham
Press & Marketing Coodinator: Elaine Carozzi
Every Day Lives In War, First World War Engagement Centre, University of Hertfordshire
https://everydaylivesinwar.herts.ac.uk/
Centre Director: Professor Sarah Lloyd
Project Coordinator: Anna Hammerin

Museum für Photographie Braunschweig, Helmstedter Straße 1, 38102 Braunschweig, Germany

www.photomuseum.de

Director: Barbara Hofmann-Johnson

Project Coordinator: Museum für Photographie Braunschweig (transport/loans/picture research): Theresia Stipp

ISBN 978-1-912260-07-2.

Published by University of Hertfordshire Press

Editing and German–English translations by Matthew Shaul

Catalogue Design: Kate Douglas

Copy Editing: Jane Housham, Sarah Elvins, (University of Hertfordshire Press), Jeremy Akerman

Acknowledgements:

The curators and organisers acknowledge the crucial early assistance and cooperation of Regine Von Monkiewitsch, chair of the Board at the Museum für Photographie, Braunschweig, Gisela Parak (former director at Museum für Photographie Braunschweig) and colleagues at Stadtarchiv Braunschweig. We would also like to acknowledge a travel grant awarded to Matthew Shaul in his role as Director of Departure Lounge in April 2015. This small award by the Contemporary Visual Arts Network, East (CVAN) facilitated the first contact between the UK partners and Museum für Photographie Braunschweig and ultimately led to the realisation of this exhibition.

Cover Image: *Children Standing in line to Deliver Glass Bottles,* 1915

End Pages: *Flowers, Still Life* (undated)

Printed by Sterling - www.sterlingsolutions.co.uk

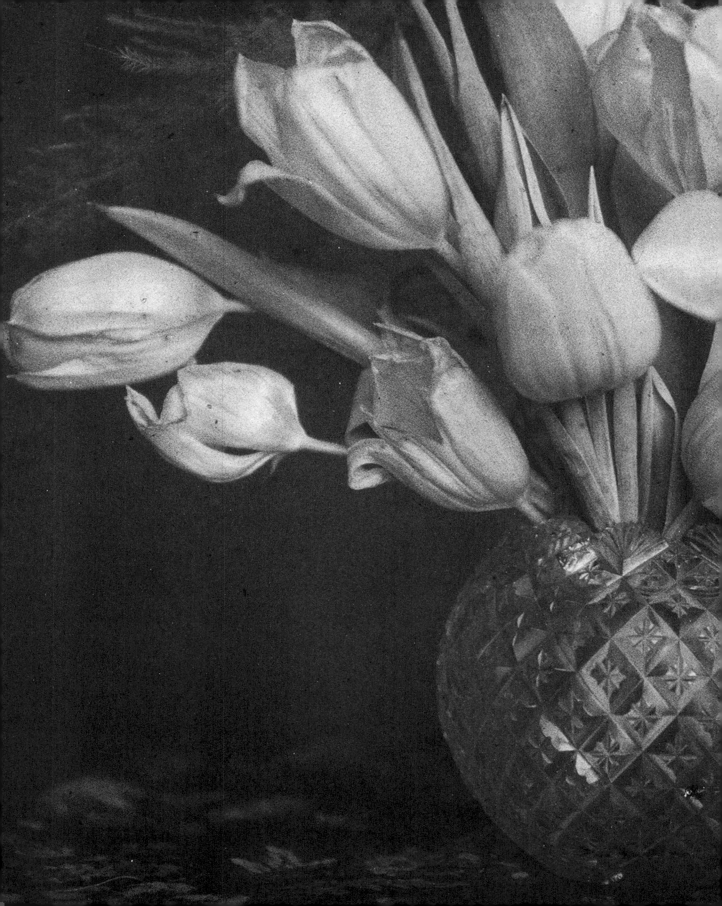